BRONZEVILLE NIGHTS

PALM TAVERN

When in Chicago, it's Palm Tavern, 446 E. 47th Street

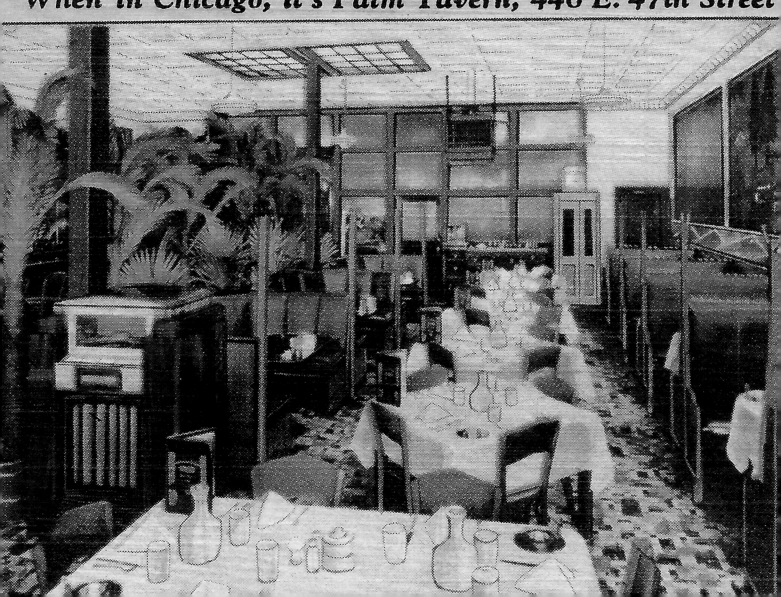

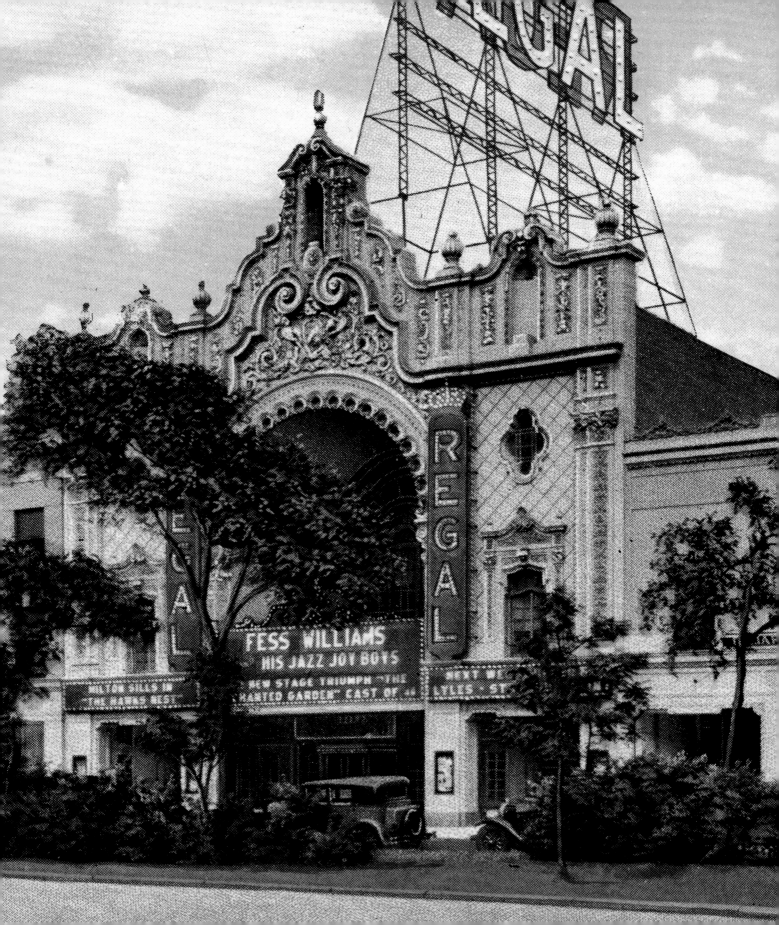

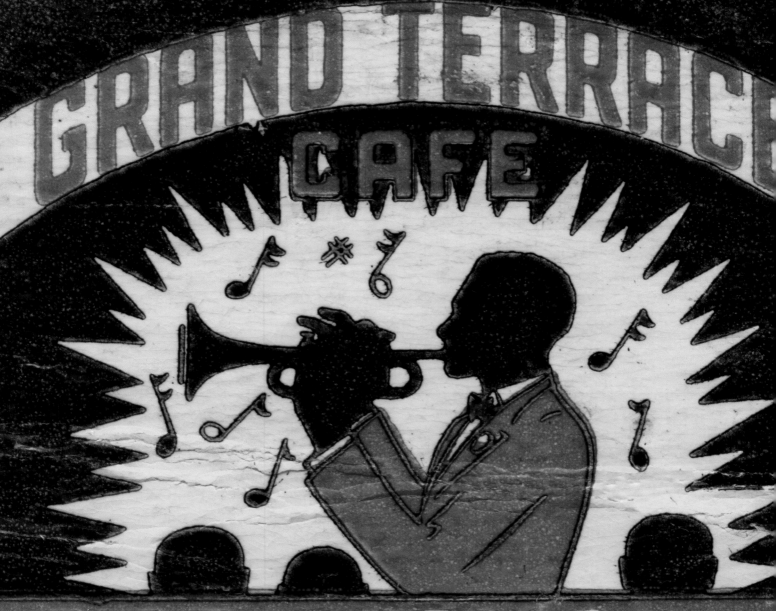

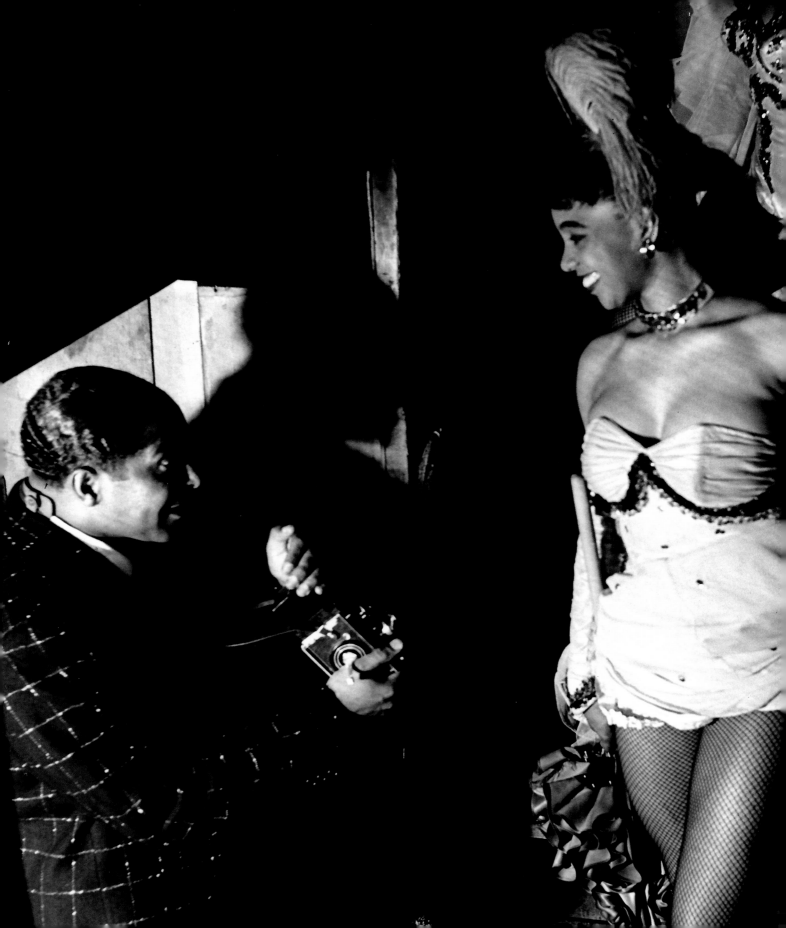

BRONZEVILLE NIGHTS

ON THE TOWN IN CHICAGO'S BLACK METROPOLIS

STEVEN C. DUBIN

**PRESENTED BY
CITYFILES PRESS**

©2021 CityFiles Press

FIRST EDITION

ISBN: 978-1-7338690-2-7

Printed in China

Produced and designed by Michael Williams.

Cover: Detail from a souvenir photo folder from the Rhumboogie Club.

2-3: Details from postcards of the Palm Tavern and Regal Theater.

4-5: Details from matchbook covers from the Grand Terrace Café and Club DeLisa.

6: Lonnie Simmons, c.1950

This page: Detail from a Club DeLisa photo folder.

CONTENTS

FOREWORD MARGO JEFFERSON

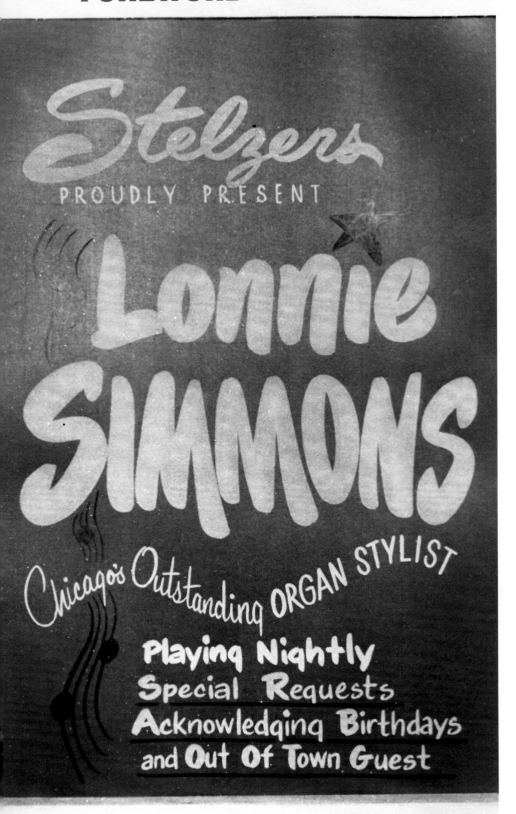

Jaunty, stylish, ebullient—
that was the jazz world
of South Side Chicago in
the 1940s and '50s. I grew
up with the legends of that
world because my parents
had been there. They never
stopped talking about its
pleasure spots, rolling the
names on their tongues. The
Rhumboogie, Silhouette,
Club DeLisa, Roberts
Show Lounge, Palm Tavern,
Pershing Lounge, Grand
Terrace. Open for business,
for pleasure, for art every
night.

And of course they never
stopped reminiscing about
Sammy Davis Jr., about Billie
Holiday, about The Berry
Brothers; about the florid
voice and flashy presence of
DJ Daddy-O Daylie; about
acrobats whose names they'd
forgotten but whose turns
and flips they could still
describe. In the 1990s, when
my mother and her friends
were in their 80s, they started
singing "Meet Me With
Your Black Drawers On" at
a Saturday afternoon club
meeting.

That world—raucous
intimate, playful—is on
panoramic view in this

treasure trove of photographs by participant-observer *extraordinaire* Lonnie Simmons. Simmons was one of those musicians whose versatility and savvy prove yet again that the first half of the twentieth century was a dynamic Golden Age of Jazz. You had the geniuses and the groundbreakers, among them Louis Armstrong, Earl Hines and Miles Davis; Duke Ellington and Count Basie; Billie Holiday and Ella Fitzgerald. But crucially, too, you had a first-rate supporting cast of hundreds (thousands nationwide), from full-time band members to pick-up sidemen—sidewomen too—all of them eager to step up and add their particular sound. I like to think of Lonnie Simmons as a jazz version of those wonderful character actors that film directors use again and again for their ability to energize every scene they enter.

Like an actor who moves effortlessly from musicals to film noir, Simmons also had a career as a Black press crime photographer. Crime as melodrama; crime as sad, sorry happenstance. He

made himself indispensable to the life of Chicago's legendary Bronzeville. These photographs show how vitally he documented that precious neighborhood nightlife and through it the ongoing life, communal and individual, of black art and entertainment. What a resource and pleasure this book is. Its collector, curator and author Steven Dubin, has arranged the photographs beautifully. They tell stories within stories. His text, wise and discerning, does the same.

Here we can savor Simmons' intimate knowledge of the performers' craft, of what it took to entertain—seduce, thrill—audiences. We savor the concentration that makes each musician bond with his instrument. We note the rapt attention and the chic wardrobes of the audiences. We feel the pleasure and wonder that clubgoers felt night after night, watching not just the stars and soloists, but also the chorines, the soubrettes, the drag queens, and (a new word to me) the stagettes, all carrying themselves with dash and glamour, displaying

and deploying their trained, toned bodies in satin and plumes, vast headdresses and high heels. What vigor, what dazzle. What strategic abandon.

And if you got lucky on one of those nights you were there, Lonnie Simmons might take out his camera and snap a photo of you looking urbane and worldly, with your date or your partner or those friends in from St. Louis or Atlanta or Los Angeles who'd arrived with a must-do list of where to go and who to see.

In the 1953 novel *Maud Martha,* Bronzeville author Gwendolyn Brooks contemplates the difference between jazz music and mainstream white pop. Popular songs, she writes, are sometimes beautiful and can cause you to rise, but they do not touch you fully.

Jazz musicians, she writes, cause you to rise and find stopping unbearable. And then they settle you back into a blissful afterglow. That's what you sought and found if you were a Black Chicagoan on a night in Bronzeville. That's what these photographs invite us to live and relive.

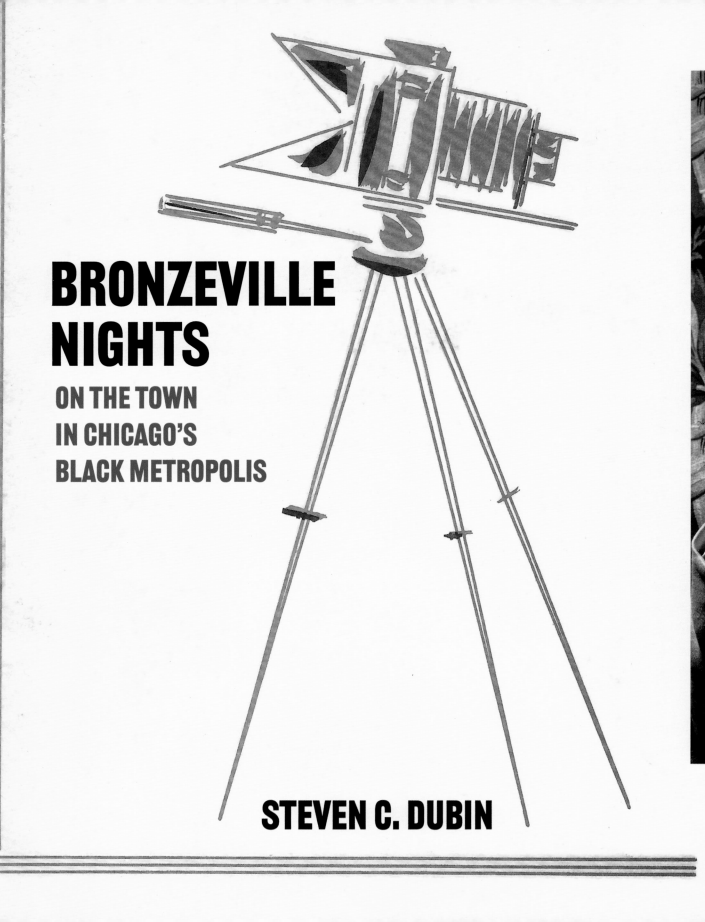

BRONZEVILLE NIGHTS

ON THE TOWN
IN CHICAGO'S
BLACK METROPOLIS

STEVEN C. DUBIN

Step inside a bygone era. Ladies wear strapless gowns of satin, taffeta, and organza, held up as if by sleight of hand. The women are smartly draped in furs: wraps, strollers, great coats. They are complemented by men with pencil moustaches who are dressed to the nines, from freshly blocked fedoras to highly polished brogues. Sharp dressers and smooth talkers, don't you imagine? Cigarette smoke curls up to the ceiling. Faces are silhouetted in half shadow. There is a sense of mystery, intrigue, and possibility.

On Chicago's South Side in the 1940s and '50s, in the African-American enclave known as Bronzeville, such tableaux were commonplace. Black and white patrons flocked to enjoy elaborately choreographed stage shows at the storied Club DeLisa or the Rhumboogie Club, the Club Congo, Cabin Inn, or the Macomba Lounge. To listen to the hippest jazz and boogie-woogie. To drink. To dance.

This world is vividly captured in the photographs

of Samuel "Lonnie" Simmons (1914–1995), a popular jazz musician and an accomplished photographer at the time. Above all, what you witness in his work is joy. The joy of seeing and being seen. The joy and art of being flirtatious. The joy of mastering one's craft. And the joy of entertaining others.

In the contemporary lingo, *nightlifers* once packed Bronzeville's *brighteries* and *danceries.* They came to listen to the most in-vogue *orks.* To gaze at *sepia artists, beige beauts,* and shapely *stagettes.* They showed up to delight in melodious *chirpers* and be awed by nimble *chorines* and *cuties.* *

Both *sepias* and *ofays* made up the audience at *black-and-tans,* clubs that served up drink and

*The *Chicago Defender* lexicon includes *nightlifers* [clubgoers]; *brighteries* and *danceries* [nightclubs]; *orks* [orchestras]; *sepia artists* [African-American performers]; *beige beauts* [attractive African-American women]; *stagettes* [stage performers]; *chirpers* [singers]; *chorines* and *cuties* [dancers or performers]; *ofays* [Caucasians]; *black-and-tans* [clubs catering to a racially mixed clientele]; *stemmers* [denizens of the "main drag"]; and *rialtos* [a cluster of places of entertainment].

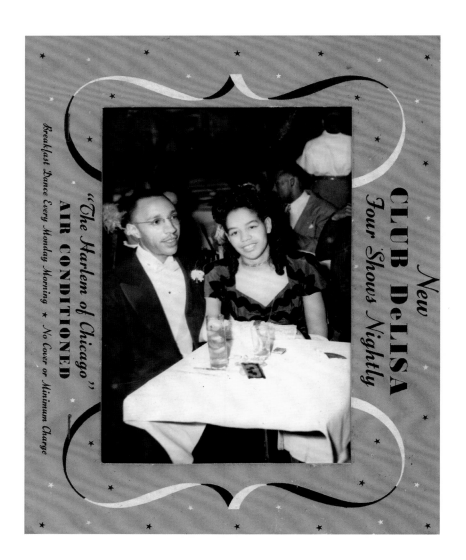

New
CLUB DeLISA
Four Shows Nightly

"The Harlem of Chicago"
AIR CONDITIONED
Breakfast Dance Every Monday Morning • No Cover or Minimum Charge

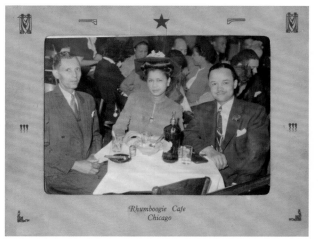

Rhumboogie Cafe
Chicago

PHOTO FOLDERS, CONVENTIONAL MEMENTOS FOR NIGHTCLUB PATRONS.

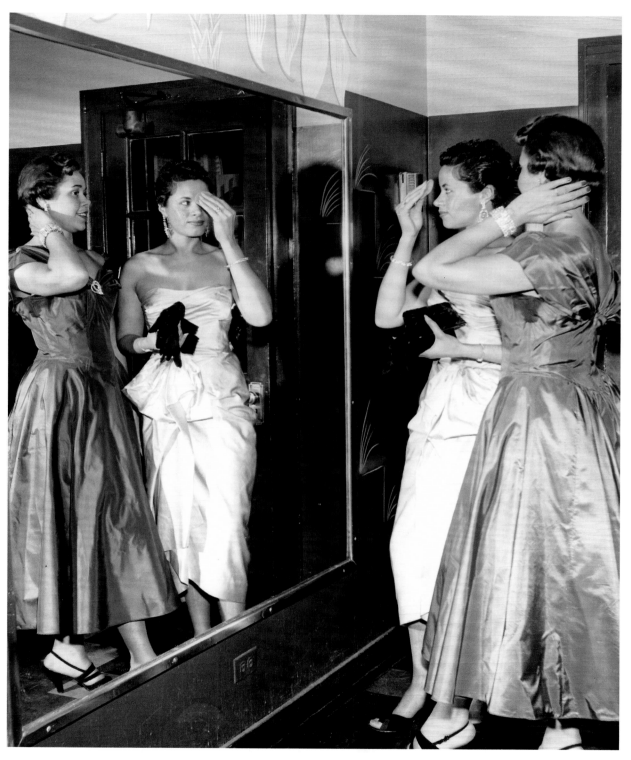

STYLISH AND WELL TURNED-OUT NIGHTLIFERS FRESHEN THEIR MAKEUP AND PRIMP TO PERFECTION.

diversion to both Blacks and whites. *Stemmers* jammed the frenzied South Side *rialtos* that successively occupied 31st, 33rd, 35th, 39th, 43rd, and 47th streets, and eventually farther south. As in film noir, these stylish nightclub patrons were creatures of the night. But the individuals in Simmons' world look festive. They are living in the moment. Everyday cares fade once they step out.

ABOUT THE COLLECTION

Simmons left behind a collection of more than eight hundred photographs owned by him and sold by his widow's estate at auction. The majority of these images are being seen by a broad public for the first time. Approximately three-quarters of the prints are 8 x 10 inches; the remainder are mostly 5 x 7s. A few larger 11 x 14-inch images also exist, made for an undated exhibition of Simmons' photos. In some instances, the smaller format photos were filed in envelopes with place names or individuals' names. On occasion, written notations appear on the

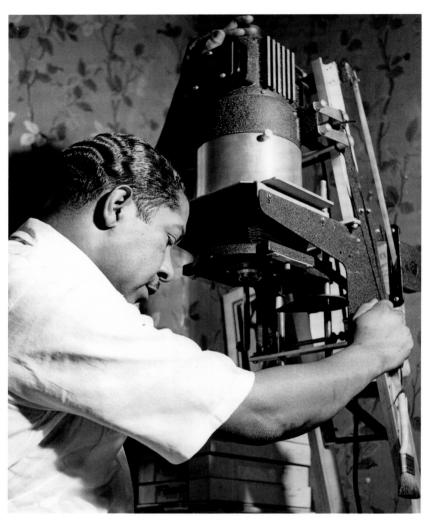

LONNIE SIMMONS COMMANDS HIS DARKROOM PHOTO ENLARGER.

reverse of the photos. Also included in the archive were newspaper clippings and other ephemera (e.g., brochures, business cards); ten 12-frame contact sheets and accompanying negatives; 24 Kodachrome stereo color transparencies; and three dozen or so Polaroids taken during the latter part of

Simmons' career.

Only a few of Simmons' photographs in this collection were published while he was alive. Certain photos include credit lines. Many do not. Credits accompany any photo attributed to a source other than Lonnie Simmons. In all remaining instances, I

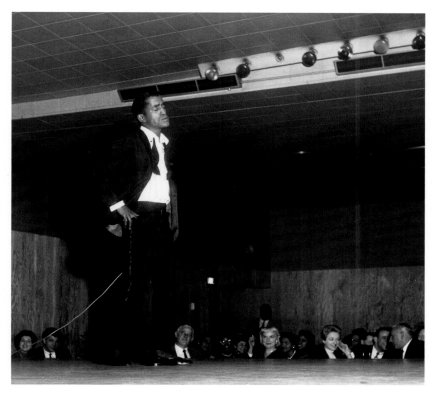

EYES SHUT, TIE UNDONE, ENERGY SAPPED, SAMMY DAVIS JR. GIVES IT HIS ALL.

inferred that Simmons was the creator.

This applies even to examples where Simmons himself appears in the shot. For instance, the atmospheric portrait of Simmons taken against a mid-century floral background is credited "By Lonnie." It is a companion to a portrait of his wife, Marietta, in the same setting. In that case, however, he is not credited. I assume that once Simmons set up the scene, he made a portrait of Marietta and also made one of himself using a timing device. Furthermore, I examined a subset of photos where Simmons is shown working as a photographer. In nearly half of them, he is directly credited. This, too, strongly suggests that Simmons used a timer for photographs in which he took an active part.

In sum, I am sharing all the information available. I conclude, based on my study of the archive and my research, that Simmons was the creator of the bulk of this work. If any misattributions have occurred, they have been unintentional.

The largest portion of the collection was taken in Chicago's Bronzeville community, a circumscribed stretch of land seven miles long and less than two miles wide. It's where 300,000 African Americans lived and worked, partied and relaxed. Lonnie Simmons snapped Ella, Lena, and Billie, Louis, Sammy, and Redd. You will recognize many other celebrities as well. Simmons was himself a performer, at Club DeLisa and Roberts Show Lounge, and at lesser-known venues such as the Beige Room and Harry's Cocktail Lounge. These were all landmarks, long-gone places that exist only in memory. And in photographs such as these.

Simmons' photos can be approached along various dimensions. He shot scenes that were artfully composed and atmospherically lit. They capture merrymakers kitted out to impress one another and to have a good time. Simmons' photos exude glamour, swagger, and coolness. His images

record a time and place that was systematically destroyed more than half a century ago. They confirm that this extraordinary social and cultural arena once existed. Moreover, Lonnie Simmons was central to it, both as a participant and as a visual chronicler.

All evidence must be evaluated, however. I will contextualize these photos against a broader socio-historical backdrop. This will reveal distinctive facets of that world that cannot be fully grasped at first glance. But there's an enigma. For whatever reasons, Simmons is virtually absent from histories of jazz. He is missing from many accounts of Chicago's vibrant African-American culture as well. It seems that Simmons slipped off our collective cultural radar. It is not clear if he was intentionally erased, deliberatively ignored, or just overlooked.

RETRACING THE ARC OF A MUSICAL CAREER

Like so many African Americans living in Chicago during the wartime and post-war eras, Lonnie Simmons hailed from the South. He was born on July 14, 1914, in Mt. Pleasant, an African-American community near Charleston, South Carolina. He was the only son of seven children born to Emily Venning Simmons and Peter Simmons. Emily was a homemaker. Peter, a blacksmith, forged the iron bars for the Charleston County Jail and made iron fences and grates.

The type of metalwork Peter produced demonstrates a direct line of tradition from enslaved African-American men who worked as blacksmiths. These skills were especially valued in Charleston, where decorative metalwork is a prominent feature of the city's vernacular architecture. Peter, in turn, passed on the skills he had inherited from his own father. A man named Phillip Simmons became Peter's apprentice. He was also a de facto adopted son, and Peter's shop was bequeathed to Phillip after his mentor's death. Phillip received a great deal of public acclaim. Those honors acknowledged

PETER SIMMONS, LONNIE'S FATHER, IN A HAND-COLORED PHOTOGRAPH.

and celebrated generations of labor done by African Americans that had otherwise been devalued and largely unattributed.

Young Lonnie was also gifted with his hands. "In Charleston, I sent myself through school making cotton hooks to lift bales," he recalled to journalist Dave Hoekstra. But what Lonnie Simmons was best at was music. Black Charleston was a musical community. The Jenkins Orphanage was supported in part by a brass band composed of its African-American orphan residents and non-orphan children from town. They marched through the

IN FOCUS: WHAT LOVE LOOKS LIKE

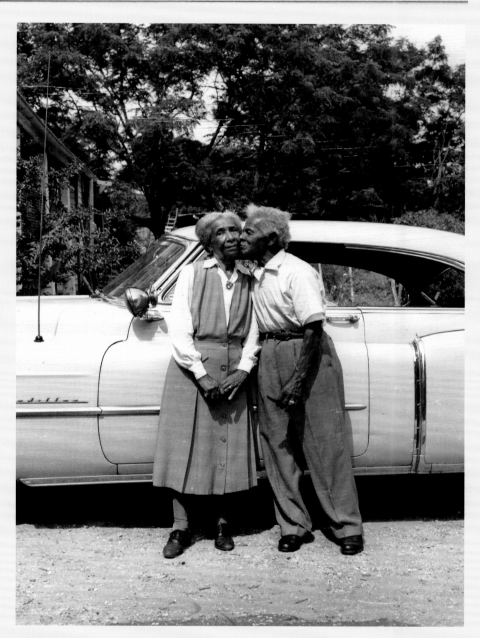

LONNIE SIMMONS' PARENTS, EMILY AND PETER, AT THEIR HOME, SOUTH CAROLINA, 1951.

Lonnie Simmons' parents, Emily and Peter, are tenderly depicted in a series of portraits he took of them at their home in South Carolina. His father looks comfortable and demonstrative in every shot of the couple. His mother appears more reticent before the camera; she reveals much less of herself. You immediately notice that they are small in stature, and unusually trim for an elderly couple. The pair kept busy throughout their lives: Peter at his forge, and Emily managing the demands of a large household. They have dressed for the occasion: Emily in a white blouse under a smartly tailored jumper. She has enhanced her appearance with a broach at her neckline and earrings. He has put on slacks and a white shirt. The couple's haircuts are strikingly similar.

They pose in front of a handsome Cadillac sedan. Peter leans over to place a kiss on Emily's cheek. He has a bit of a mischievous look; she is being modest, reserved. You get the impression that she wants to be done with this as quickly as possible. Their love for one another is obvious. It is evident that they are a couple that has shared a lifetime together.

Peter's physicality is displayed in additional images as he forges metal in his blacksmith shop, skippers a small fishing boat, and aims a rifle that could very well be as long as Peter is tall. Together, Simmons' parents project a sense of deep intimacy and quiet grace.

streets of Charleston to solicit donations, dressed in castoff uniforms from The Citadel Military College. "They used to come into my neighborhood, and I would stop whatever I was doing and follow them all over the city," said Freddie Green, Simmons' childhood friend.

Lonnie and Freddie, like many other African-American youngsters in Charleston, taught themselves to play music so they could join the Jenkins band. Peter Simmons bought his son a tenor saxophone from Sears, and Lonnie joined the orphanage band when he was ten. Freddie Green enlisted with his ukulele. From the volunteer band they teamed up with the Nighthawks, a small professional group that played at all the Black dances in and around town. "Although I was very young, they let me join the band, and I earned $3 a night," Simmons reminisced to Charles Walton during his "Bronzeville conversations" series.

The taste of being a musician shaped the remainder of Simmons'

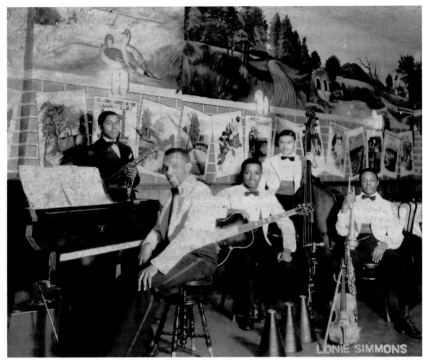

HIPPODROME PHOTO STUDIO, N.Y.

AT AGE SIXTEEN LONNIE SIMMONS [FAR LEFT] AND HIS RHYTHM CHICKS, 1930.

life. Although he felt close to his parents, he left them at the age of 15, drawn to New York City to pursue his creative passion.

Simmons sailed from Charleston with just $15.50. He spent all but fifty cents on the boat fare. "I stayed with my sister and knocked around town and met a lot of great musicians," Simmons explained to Walton. His sister Lillian, who was in her 20s, lived on West 126th Street in Harlem and was friendly with entertainers. "All the musicians hung out

at the Rhythm Club in New York, and some of them seemed to think I had a little potentiality," Simmons told Hoekstra. He did amazingly well, amazingly quickly.

Simmons landed a job at a nightclub in Harlem through one of Lillian's friends, a musician who needed help for a New Year's Eve party. Simmons brought along Freddie Green, his Charleston bandmate. "Freddie and I were added to the regular group, and we made $10 a week. We stayed there at the Yeah

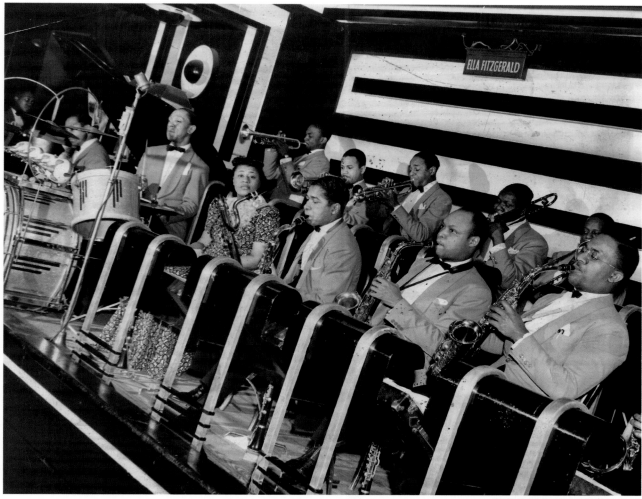

THE CHICK WEBB ORCHESTRA FEATURING ELLA FITZGERALD. SHE SITS NEXT TO LONNIE SIMMONS.

Man Club for quite a while," Simmons told Walton. They took on many other gigs as well, playing Harlem's Tillie's Chicken Shack and the Exclusive Club, and Greenwich Village's Black Cat Nightclub.

Freddie Green's son Alfred wrote, "Opportunities to work as a musician often materialized through Lonnie's and Freddie's abilities to market their skills the night before by jamming or making the rounds acquiring contacts. . . . The Jenkins [band] experience had given them a distinct edge over the hordes of black musicians migrating from the South and other parts of the country; Freddie and Lonnie were musically literate."

In 1936, Freddie Green joined Lonnie Simmons' Rhythm Chicks. They were noticed by talent agent John Hammond Sr., who discovered Bob Dylan and Bruce Springsteen years later. Hammond arranged

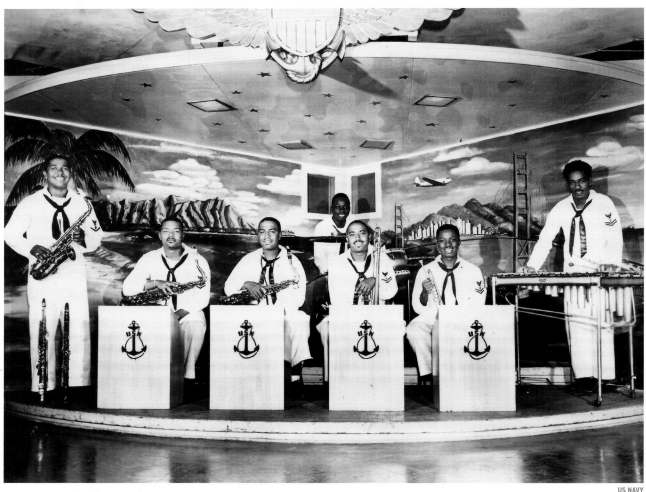

SIMMONS [LEFT] SEXTET AT PEARL HARBOR, 1945, INCLUDING HARLAN FLOYD (TROMBONE) AND EUGENE GILBEAUX (PIANO).

an audition for Freddie and Lonnie at the Black Cat in early 1937, attended by Count Basie, Benny Goodman, and others. "He put me with Fats Waller; he put Freddie with Basie," Simmons recalled to Hoekstra. Green switched from banjo to swing guitar and played with the Count Basie Orchestra for nearly fifty years. Simmons played tenor sax with Fats Waller for three. He continued, "Fats was fun, even though he drank a lot," Simmons said. "[H]e was able to use a lot of different lively arrangements on 'Honeysuckle Rose' and 'Ain't Misbehavin'. He created such a happy sound."

Simmons left Waller's band after a few years and then made a sweeping musical circuit through Harlem, playing with the Savoy Sultans, the house band at the Savoy Ballroom, and at such legendary venues as the Apollo Theater and Small's Paradise. After Ella Fitzgerald's band leader Chick Webb died in 1939, Simmons joined

Ella's newly-formed band. They toured together and sustained a casual intimacy over a long period of time. Alfred Duckett reported that Simmons telephoned Fitzgerald, reaching her at the star's dressing room of the Chicago Theatre. Sensing something wrong in her voice, Simmons rushed to see his dear friend, bearing ham hocks and greens. They did not forget one another after their professional relationship ended. And neither of them betrayed their Southern roots.

Simmons moved from New York to Chicago around 1942. The *Chicago Defender,* a daily and weekly newspaper that covered African-American life nationwide, documented Simmons' early career in Chicago. In 1943 columnist Ole Nosey reported that "famed Lonnie Simmons and his gang" were playing at the DuSable Lounge in the DuSable Hotel, 764 East Oakwood Boulevard, on the South Side. He was identified in the newspaper as "one of the nation's most popular musicians." But Simmons was called to

report to the Great Lakes Naval Training Center by year's end. He was sent to the Pacific theater of war in May 1944.

The *Defender's* Ole Nosey also commented upon Simmons' romances. In early 1943 it reported, "Dorothy (Call me Dot) Barnes and Lonnie Simmons are still working up that heatwave." Dorothy Barnes was the widow of bandleader Walter Barnes, who died along with 206 others in the catastrophic 1940 Rhythm Club Fire in Natchez, Mississippi. The paper covered the couple as if they were royalty. "Beauteous Dorothy Barnes, [is] vacationing in St. Louis, showing off fine jewels given by b.f. Lonnie Simmons," noted a columnist.

In 1948 Ole Nosey reported, "Savannah Churchill and Lonnie Simmons are not married as reported along theatrical row." Churchill, the singer with a number one rhythm and blues hit "I Want to Be Loved (But Only by You)," was appearing with Simmons on stage in Chicago. Simmons told a *Defender*

columnist that they had been engaged six years earlier in New York City. But now, he said, they were just friends.

Simmons was stationed at Barber's Point Naval Air Station, Hawaii, just west of Pearl Harbor, in 1944 and 1945. He led a sextet that played across the islands for the U.S.O. and at servicemen's clubs. He also hosted a radio show that was broadcast on KGMB from the Royal Hawaiian Hotel in Honolulu. It was on the naval base in Hawaii that Simmons, already an accomplished saxophonist, learned to play a church organ. Simmons switched instruments when one of his band members took ill.

The visual record that Simmons left reflects a clear division in his musical career between these two instruments. Liner notes to a Chess Records compilation of Chicago jazz present a more complex picture, however. When Simmons produced *Lonnie's Blue* in 1953, he first recorded the parts written for organ and overdubbed them with a track he laid down on his sax.

Simmons repeatedly assembled and reconstituted the musical groups that he headed. Their names crescendoed in a succession of superlatives. The Lonnie Simmons Quartet. Lonnie Simmons and His Combo of Swing. Lonnie Simmons and His Modern Band. Lonnie Simmons and His Great Band. Lonnie Simmons and His Augmented Band. Lonnie Simmons and His Brilliant Orchestra.

Simmons returned to Chicago from the war in late 1945. He played at the El Grotto Supper Club in the Pershing Hotel, 6412 South Cottage Grove Avenue. Soon thereafter Simmons served as bandleader and talent manager at the Pershing's renamed Beige Room, a place where he remained through the decade. Mabel Scott and Charlie Parker performed at this popular place, and it was a spot favored by boxing champ and local hero Joe Louis and wife Marva. Simmons severed his ties at the Pershing after he was told to reduce the size of his ten-piece band to eight. "If the band is cut, old music would automatically become void as every man in the

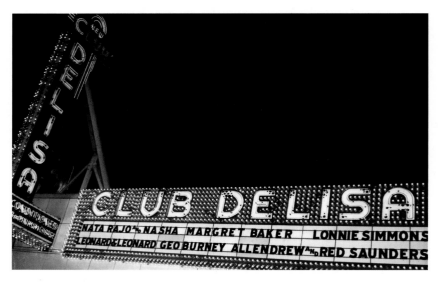

NEW CLUB DELISA MARQUEE SHOWCASING LONNIE SIMMONS.

band doubles," he objected, according to information in his personal scrapbook. It was a rare public controversy for Simmons.

Simmons moved about seven blocks east to Harry's Cocktail Lounge, 432 East 63rd Street, and in 1950 took a temporary gig at Club DeLisa, 5521 South State Street. Two weeks evolved into an eight-year stint, until the club closed in 1958. Simmons was considered the "sustaining" or fill-in act while the Red Saunders Band went on break. And yet, photographs of the Club DeLisa marquee show Simmons headlining, above Saunders.

Jet magazine reported that

Simmons played the jazz organ and Saunders led his band at Club DeLisa's final show. They both decamped to work at Roberts Show Lounge, 6622 South Parkway Boulevard (now Martin Luther King Drive). Roberts Show Lounge competed with Club DeLisa for booking top performers and attracting crowds. In 1957 owner Herman Roberts spent $250,000 expanding his club in order to attract nightlifers. But the era of the nightclub was waning.

Roberts Show Lounge joined a long roster of shuttered South Side venues when it closed in 1961. This was the world that Lonnie Simmons documented for years.

BRONZEVILLE: THE LAY OF THE LAND

A prime source for putting Simmons' photographs in context is *Black Metropolis, A Study of Negro Life in a Northern City,* the epic book about Bronzeville. It was published in 1945, the year Simmons returned to Chicago.

The study began with information gathered by a large group of researchers employed by the Works Progress Administration, from 1935-1940. Sociologists St. Clair Drake and Horace R. Cayton Jr. devoted several more years investigating the South Side area that was home to the majority of Chicago's Black residents in greater depth.

What they discovered was a stark, overcrowded "city within a city," plagued by high disease and death rates (from infant mortality to tuberculosis) and saddled with un- and underemployment.

As Drake and Cayton memorably wrote, "Stand in the center of the Black Belt—at Chicago's 47th St. and South Parkway. Around you swirls a

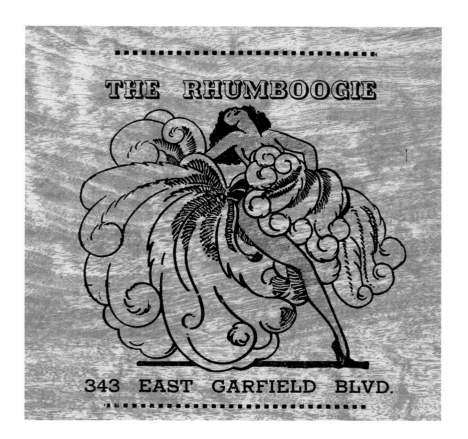

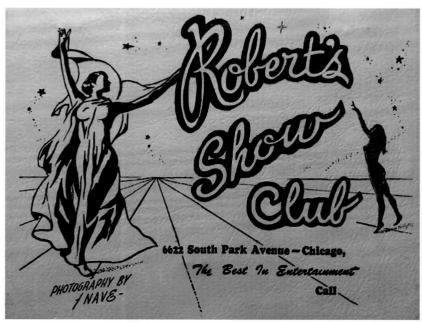

SOUVENIR PHOTO FOLDERS FROM TWO POPULAR SOUTH SIDE NIGHTCLUBS.

25

IN FOCUS: A MAN ABOUT TOWN

Lonnie Simmons as a young man has the look of a merry-maker. Even something of a scamp. He loves the camera. And it endows Simmons with a bold sense of self-confidence. Simmons is blessed with dancing eyes and a winning smile. His thick dark hair sweeps back from his temples in rows of textural waves. Simmons is smartly dressed; he appears charming and appealing. Simmons also comes across as a take-charge kind of fellow. His natural good looks, exciting career, and celebrity friends made him sought after by fashionable ladies. Simmons left a trail of broken hearts before he married Marietta Finley, with whom he spent 37 years.

The Simmons archive provides a sweeping overview of the Bronzeville nightclub scene. Until now, glimpses of this time and place existed in bits and pieces. The discovery of this body of work makes Lonnie Simmons the most prominent eyewitness we have. The archive simultaneously reveals the contours of his own life. Lonnie Simmons became the favorite subject of Lonnie Simmons. It is highly likely that he shot many of the photographs where he is eating, socializing, or kidding around with his high-flying friends. And thereby further honed his craft.

We also see Lonnie and Marietta relax in their comfortable South Side home—after they have stepped out of their formal attire. The couple enjoys well-attended birthday parties and holiday get-togethers in their basement recreation room. Simmons enthusiastically pursues an additional passion, fishing. These personal shots add another dimension to this larger-than-life personality.

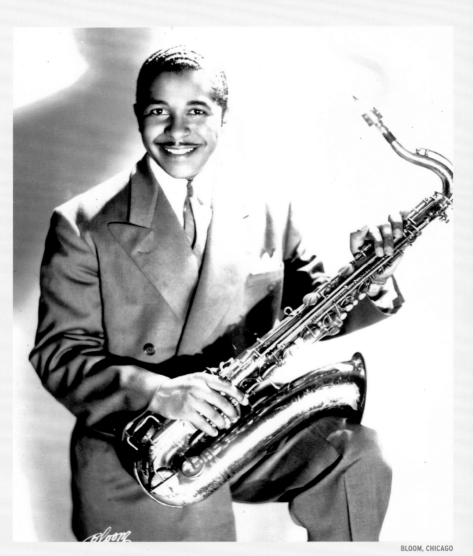

BLOOM, CHICAGO

SIMMONS RADIATES CHARISMA IN THIS EARLY PROMOTIONAL PHOTO.

continuous eddy of faces— black, brown, olive, yellow, and white. Soon you will realize that this is not 'just another neighborhood' of Midwest Metropolis." A sample of jazz and blues tunes celebrating the area includes "Indiana Avenue Stomp," "State Street Jive," and "Mecca Flat Blues."

Some residents were professionals: doctors, dentists, lawyers, and accountants. But most men worked menial, hazardous, low-paying jobs in the stockyards, coal yards, and steel mills. Women worked as domestics or charwomen, took in laundry, or labored alongside men in slaughter houses. And they were the lucky ones.

Many Black people responded to their devalued economic circumstances by searching for "good times," Drake and Cayton argued. "When work is over, the pressure of the white world is lifted," they wrote. "Within Bronzeville Negroes are at home. . . . In their homes, in lodge rooms and clubhouses, pool parlors and taverns, cabarets and movies, they can temporarily shake off the incubus of the white world."

Bronzeville, like Harlem, has been romanticized. Racial restrictions, formalized in law or enforced by customary practices, unintentionally created a rich and complex local culture. Many of Bronzeville's residents may have been economically disadvantaged. But they inhabited a precinct that was steeped in creativity as well. Elegance coexisted with desperation, resourcefulness flourished in the face of many limitations.

The boundaries of Bronzeville shifted over time, ballooning southward. Restrictive housing covenants strictly determined where Blacks were permitted to live at all times. The "invisible barbed-wire fence," Drake and Cayton called it. The "successful and ambitious" can't get out, they wrote, and the poor are not given enough space or opportunity to change. Segregation dictated that different economic classes lived in close proximity, generating a rich jumble of individuals, values and experiences. The sheer mass of people in this section of South Side Chicago, combined with workers flush with wartime wages, fueled a bourgeoning of the arts and entertainment.

The expansion of the Black South Side was the result of the Great Migration, a massive influx of African Americans from the rural South to the urban North. Beginning during World War I and sustained until well after World War II, these sojourners felt the push of oppressive racist practices in the South. Many were literally running for their lives. They were also pulled by the prospect of better jobs and increased freedom in the North.

Centenarian Timuel D. Black Jr., Bronzeville's most noted contemporary chronicler, recalled that experience in his 2019 memoir *Sacred Ground*. "Understand that our family moved not simply to Chicago, but specifically and intentionally to the South Side of Chicago," he wrote. Author Black relished fighting for the rights of workers

and the racially oppressed, cultivating friendships, and searching for good times. He spent memorable evenings at the Rhumboogie Club, Palm Tavern, Regal Theater, and Club DeLisa.

"What is it about jazz that grabs me, calms my spirit, focuses my mind?" the 99-year-old Black asked. "I enjoy jazz almost every evening. It is my tranquilizer after the cares of the day. It provides memory and imagination and relaxation. It shows that there is no monopoly on joy."

Not many physical traces remain from these times. The DuSable Hotel on Oakwood Boulevard, where Lonnie Simmons made his Chicago debut, is now a park. The Pershing Hotel and Club DeLisa are vacant lots, as is Harry's Cocktail Lounge. Roberts Show Lounge was torn down years ago, replaced by the New Beginnings Church.

Those absences endow Simmons' photographs with a heightened importance today. The body of work he left is the most vivid record we have of this monumental time in Chicago history.

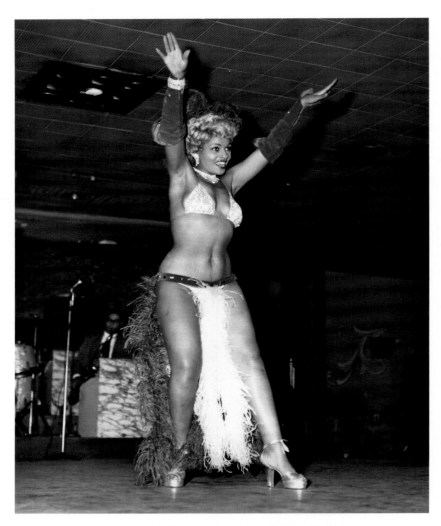

A CURVACEOUS CHORINE IN AN ELABORATE, SKIMPY COSTUME.

NIGHTLIFE AND THE UNDERWORLD

Beneath the surface glitz and glitter was a web of connections that controlled the profits from all the clubs, taverns, and theaters. Dempsey Travis, a real estate entrepreneur before he became a writer, noted in *An Autobiography of Black Jazz,* "The keepers of the cash box were usually Jewish or Italian and, occasionally, they were mob-connected Blacks. . . . Wherever there was a generous segment of Jews, Italians and Blacks coexisting within an urban area, the results favored jazz music." This was prime

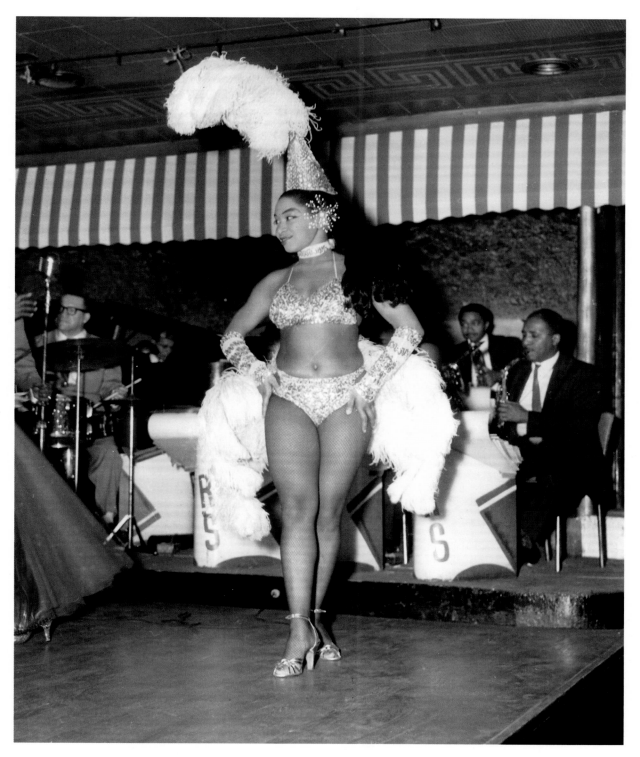

A SHAPELY STAGETTE OUTFITTED IN SEQUINS, EXTRAVAGANT FEATHERS, AND A WINNING SMILE.

territory for gangsters, and the links between the four Italian brothers who owned Club DeLisa, the mob, and mob violence were strongly suspected. And for good reasons.

The presence and influence of the mob in the Black Belt was common knowledge. The Grand Terrace Café, at 317 East 35th Street, was operated by the Capone syndicate, as was the Cotton Club in neighboring Cicero. Historian Adam Green states unequivocally that the DeLisas, owners of the eponymous nightclub, were members of the Capone syndicate. African-American Studies professor Clovis E. Semmes likewise traces the connections between the world of entertainment and the mob, noting, "organized crime connections helped to sustain the economic viability of the Regal [Theater], as it addressed the challenges of the Great Depression." Moreover, he observed, "Capone wanted the best jazz musicians and other top Black talent in the swank clubs and cafés where he sold his bootleg liquor and sponsored other illegal activities."

Capone went to prison in 1931, two years before Club DeLisa opened. And yet, the entanglement of the mob with nightlife venues continued in his absence. Semmes concluded that for people working in the entertainment sector, pay-offs to the Chicago crime syndicate were "a normal business expense."

Novelist Richard Wright described Club DeLisa in the following way: "The place is Italian owned, and caters, it is rumored, to 'gangster trade.' It is very popular with the more daring 'nighters-out.'" In fact, anything you read from this period places Club DeLisa in the top three most popular entertainment venues. Oftentimes in the top two. And in many peoples' minds, it was number one.

BLACK-AND-TAN, BUT NOT SO BLACK AND WHITE

Bronzeville was a self-contained community in many respects. But Blacks of necessity interacted with whites who were shop owners or landlords. These relationships were inherently unequal. Bronzeville was also a place where some whites sought illicit thrills such as interracial sex and drugs. Certain clubs were noteworthy for being rare places where Blacks and whites could relax in one another's company. Black-and-tan joints like Club DeLisa were anomalies of openness and nonconformity in the pre-Civil Rights era. But they were only temporary respites from the status quo. Dominant social norms and racial segregation were not completely checked at the door with a beautiful coatroom attendant. The larger world still seeped in.

Club DeLisa had it all. Spicy revues such as Sepia Parisian Nights, Bronzeville Frolics, Winter Time is Swing Time, and Murder in the Moonlight might knock your socks off. The *Defender's* George Daniels called them "fleshy floor shows," whereas a *Pittsburgh Courier* obituary by Earl J. Morris honoring DeLisa show producer Earl Partello noted, "[He] glorifies the American sepia girl. His chorus is a rainbow

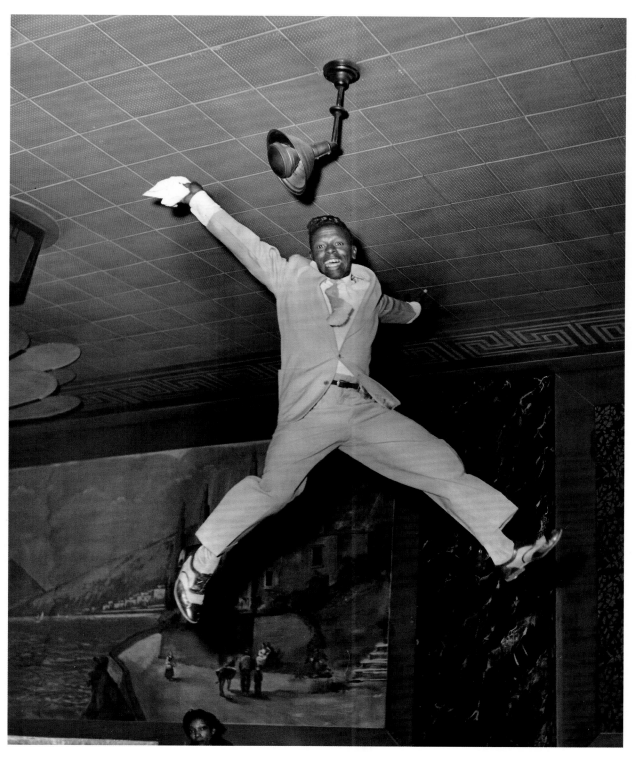

GEORGE BURNEY AND HIS FLYING FEET, ONE OF MANY ACROBATIC ACTS THAT WERE A NIGHTCLUB STAPLE.

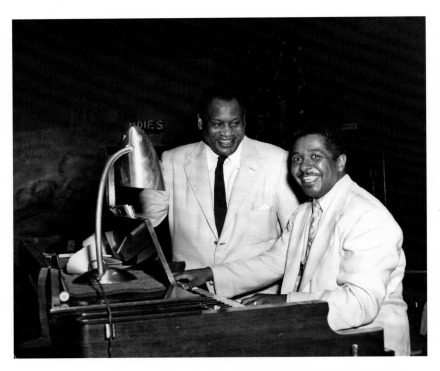

SINGER, ACTOR, AND POLITICAL ACTIVIST PAUL ROBSON WITH SIMMONS.

ensemble of girls ranging in complexion from peach to burnt toast." But should you experience bad luck playing blackjack, poker, or dice in the equally popular gaming area downstairs, you could lose your shirt.

Shirley Nelson was a controversial Bronzeville figure. She had seen everything. Up close. Nelson skidded from being a righteous church singer to becoming a prostitute and drug addict. Recalling Club DeLisa in a 1959 *Defender* article, Nelson confirmed, "the bar used to jump with prostitutes and pimps and addicts in the early morning."

Over time, Club DeLisa hosted boxing and wrestling matches, roller skating, and amateur entertainment nights. It staged hat contests and charity benefits. The club also became home to the Mayor of Bronzeville Inaugural Balls. One of the walls of the club featured a mural of an Italian village nestled into the hills. Tall cypress trees and a peasant woman walking along an elevated mountain pathway completed this imagined scene from the owners' home

country. Club DeLisa's menu specialized in "Italian and American Dishes" of the day such as chicken (Southern style), Steak Mount Vesuvio, and varieties of spaghetti, ravioli, mustaccioli and scaloppini. The club drew many luminaries, including Bing Crosby, Bob Hope, Gene Autry, Mae West, Louis Armstrong, Paul Robeson, and boxing champ Joe Louis, who co-owned the Rhumboogie Club, about one-half mile east.

Club DeLisa attracted more than a celebrity clientele, however. Author Dempsey Travis reminisced, "I heard loud music coming from Club DeLisa around the corner. It was Saturday night, and the brothers were spending their stockyard paychecks." Journalist Dan Burley likewise noted that everyday people relaxed in the neighborhood's clubs and theaters on the weekends, "Men who worked at the stockyards, at the Argo Starch mills, the steel mills in Gary or at International Harvester."

As noted, Club DeLisa was a black-and-tan venue, one drawing a mixed

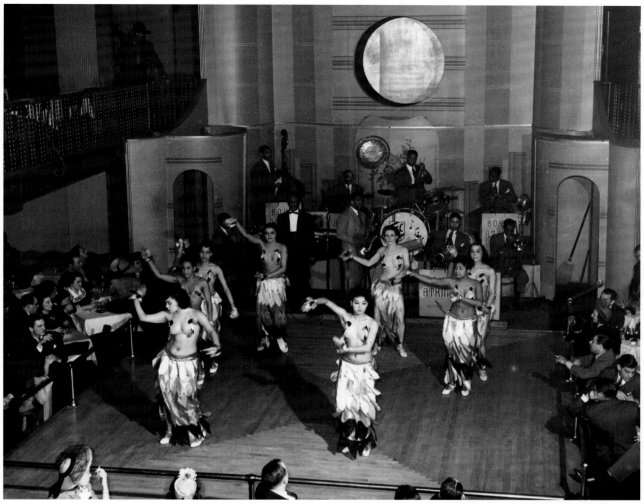

RINGSIDE AT "A NEGRO CABARET," LIKELY SWINGLAND CAFÉ, 343 EAST 55TH STREET.

African-American and white audience. It opened in 1933 during the Chicago World's Fair, officially known as the Century of Progress International Exposition, and operated until 1958. The DeLisa brothers drew upon their experience as bootleggers during Prohibition (which ended in December 1933) to launch the club. They were obviously capitalizing on this expansion of fresh business opportunities.

Early on, they called their nightclub DeLisa Gardens, located at 5512 South State Street. Enjoying immediate success, the owners enlarged the seating capacity in 1935. One in-the-know article in the *Chicago Defender* in 1938 stated, "The DeLisa is truly a new haven for Lindy Hoppers, jitterbug and floy-floy addicts of the day—to say nothing of the swanks."

The place often made headlines, not always positive. Two patrons were

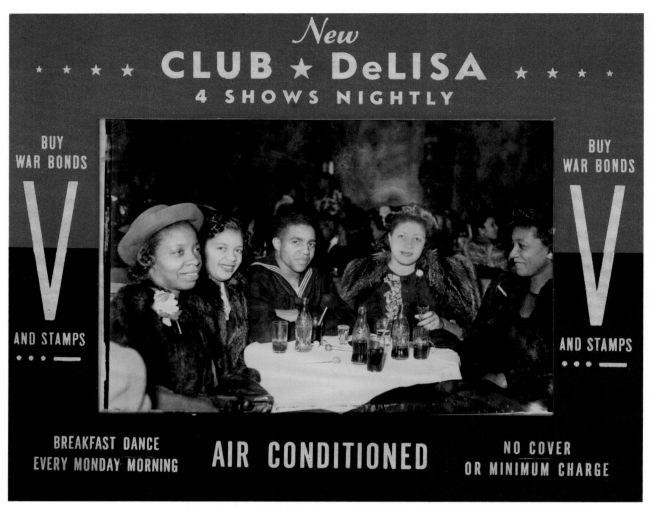

New
CLUB ★ DeLISA
4 SHOWS NIGHTLY

BUY
WAR BONDS

V

AND STAMPS
● ● ● ▬

BUY
WAR BONDS

V

AND STAMPS
● ● ● ▬

BREAKFAST DANCE
EVERY MONDAY MORNING

AIR CONDITIONED

NO COVER
OR MINIMUM CHARGE

ON THE HOME FRONT, THE WARTIME ECONOMY STUFFED WORKERS' POCKETS AND STOKED A DESIRE FOR REVELRY.

wounded during a shooting in the club, also in 1938, but all charges were dropped after the parties involved agreed it was accidental. And in 1941, an after-hours blaze destroyed the club. A porter died and six others were injured. The DeLisas rebuilt across the street. Thereafter, it was known as the New Club DeLisa.

Controversy was never far away. During World War II, the Navy declared Club DeLisa and the Rhumboogie Club "off limits" to white sailors. In an undated article in the *Defender,* a spokesperson from the University of Chicago claimed, "We are trying to protect Negro womanhood from approaches of white sailors."

The police instituted a ban on women sitting at bars that same year, presumably targeting prostitutes looking for customers. To comply, co-owner Mike DeLisa had "For Men Only" painted on the club's bar stools. Club DeLisa and other venues

IN FOCUS: IN THE SWING OF THINGS

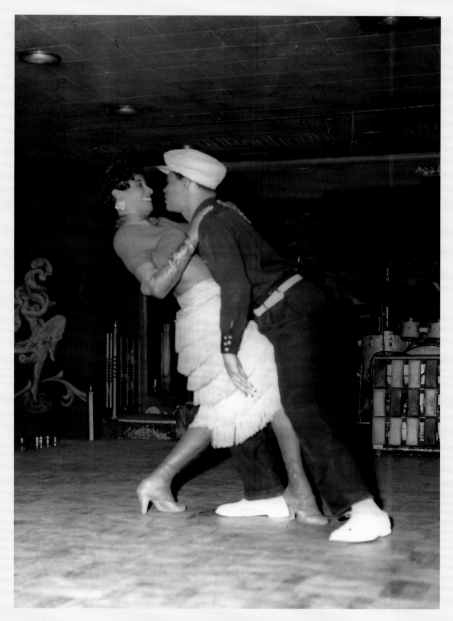

HARMONIZED FUN ON THE DANCE FLOOR.

These dancers belong together. Their bodies are beautifully synchronized. The initial impression is that he has gone limp and is leaning heavily on his partner. She appears to be both holding him up and pushing him away. But just look at her smile. It is perfect enough to be featured in a toothpaste commercial. And it telegraphs her pleasure in being with him.

The man is dressed in a casual but modish manner. The woman has slipped into a flapper-style dress, a plain pullover, and stylish shoes. She has glammed up her outfit with a scarf tied around her neck, bold earrings, and a pair of gloves that look a bit out of place with everything else she has chosen. Her carefully made-up face and daringly short hair give her an appealing, sassy look. The woman's outfit is attractive and flattering without being brassy. That sets her apart from the stage chorines of the era who were outfitted in skimpy costumes that were embellished with feathers and sequins. Exaggerated high heels and towering headdresses often capped off their ensembles.

Were these dancers professional performers? Or customers? In either case, it is evident that they are having great fun. And they project a playful sensuality. The dance floor is theirs; this grants them a monopoly on attention. Their body language calls to mind a well-known shot by West African photographer Seydou Keïta. His dancing couple leans into one another, their heads nearly touching. It conveys the same stirring sense of being young and stepping out.

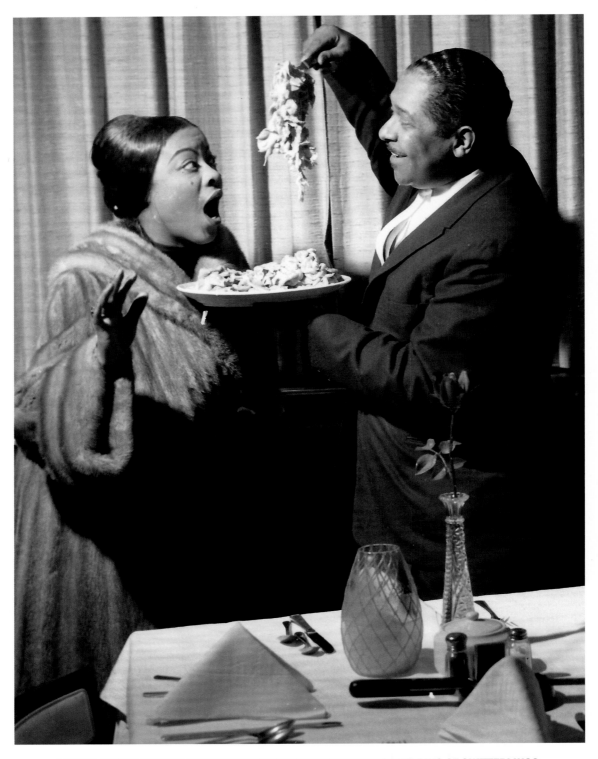

LONNIE SIMMONS TEASES SINGER LAVERN BAKER WITH A LARGE HELPING OF CHITTERLINGS.

also ran afoul of the law for allegedly selling alcohol to underage sailors. But according to Dempsey Travis, the DeLisa brothers retained a well-connected business administrator who was savvy about preventing police interference.

Club DeLisa staged four shows nightly, as well as an immensely popular Monday morning breakfast dance. It catered primarily to entertainers from other clubs, beginning at 7 a.m. Different clubs sponsored similar events on other days of the week.

Featured acts included Little Miss Sharecropper (LaVern Baker), Little Miss Cornshucks (Mildred Jorman), Butterbeans and Susie (Jodie and Susie Edwards), and Givedam Jones and his trained chickens. Were these monikers calculated to evoke the Southern roots of many of the audience members?

Names such as The Hottentots as well as Tony Fabro and his Jungle Rhythm Orchestra might make a contemporary reader wince, whereas Charles McBride, the "Ebony Bing Crosby,"

echoes with equal parts of clever self-promotion and social striving. Lost to history are the particularities of Henriene Barker's "wash tub act."

A *Defender* article headlined a report on a New Year's Eve celebration with "Many Races Mix at Mike DeLisa's Gay Spot." As Simmons' colleague Red Saunders reminisced to the *Defender's* Michael L. Culbert in 1973, "We had an intermixture of the races before." He noted, "Whites could come to the South Side and the racial climate wasn't as thick as it is now." This was written in the aftermath of the devastating racial conflicts of the late 1960s.

The actual situation in black-and-tan clubs, however, replicated the racial status quo rather than disrupted it. "All the clubs had one thing in common, and that was a Jim Crow seating policy in the heart of the ghetto," Dempsey Travis wrote. "The best tables in the house were always reserved for whites. It was a common sight to walk into any of the class South Side clubs and see white folks hogging the ringside seats

while Blacks sat on the side and in the rear."

In his defense, co-owner Jim DeLisa insisted that this situation did not represent prescribed Jim Crow practices. Rather, Black bouncers instituted this arrangement on their own initiative in the belief that it "optimized tips." In other words, employees created their own version of racial profiling. People of different races might patronize the same places, but they remained detached from one another to a degree. And for the poorer residents of Bronzeville, the ritzier clubs were as inaccessible as they would have been if they were miles away.

The color discrimination widely noted *among* African Americans was evident as well. Taxicab entrepreneur Herman Roberts, owner of Roberts Show Club, admitted in *An Autobiography of Black Jazz,* "I hired yellow ["high yellow" or "yellow bone," i.e., light skinned African Americans] bartenders with pretty hair and girls who looked like that, too, because I thought it was good for business."

None of this should be

surprising. Nightclubs aim to maximize profits, not subvert cultural assumptions or reconstruct social arrangements. Lest these local Chicago practices be judged too harshly, however, keep in mind that some venues, such as Harlem's legendary Cotton Club, maintained a whites-only policy.

Two of the DeLisa brothers died in 1957 and 1958. Simmons photographed both funerals for the *Defender:* Mike DeLisa's service at St. Dorothy Catholic Church on 78th Street and Louis DeLisa's at St. Anne Catholic Church on 55th Street. Their club closed a month after the death of Louis DeLisa. The unfortunately named Burning Spear Club, which later took over the New Club DeLisa space, was gutted by a fire in 1974. This once fabled address is now part of a vast urban prairie, hosting only scattered residues of the built environment. It is a phenomenon found in many formerly vibrant African-American communities in major cities.

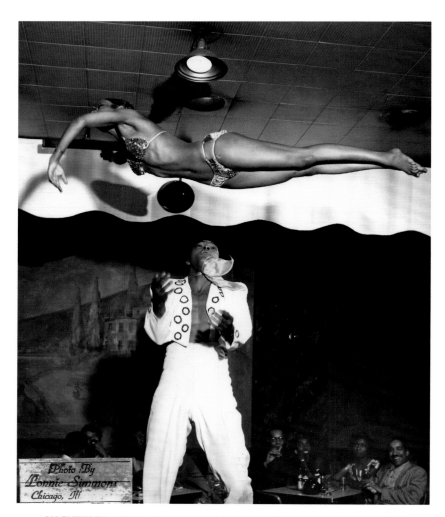

AN ENTERTAINER THRILLINGLY LAUNCHES HIS PARTNER INTO THE AIR.

HIGH STEPPING

A significant portion of the Simmons photo collection captures the gravity-defying acrobatics of nightclub performers. They leap gracefully into the air. Jump over one another. Or are suspended atop their partners. In several cases it is unclear how to even hold his photographs. Which way is up? Which is down? It is only when you see audience members dwarfed at the bottom of the frame that you realize some of these artists have been caught at the zenith of a full flip. They appear to be walking on the ceiling. That's how good Simmons was at his craft. These particular photos

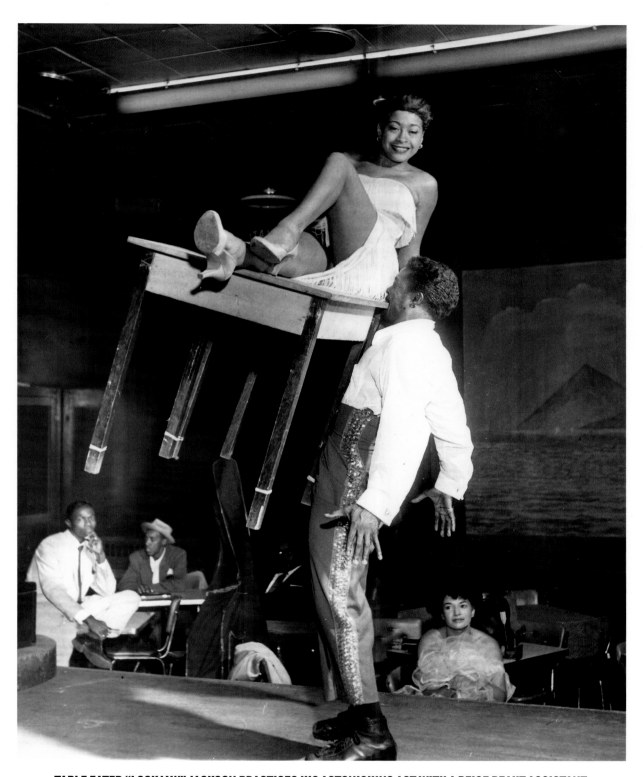

TABLE EATER "LOCKJAW" JACKSON PRACTICES HIS ASTONISHING ACT WITH A BEIGE BEAUT ASSISTANT.

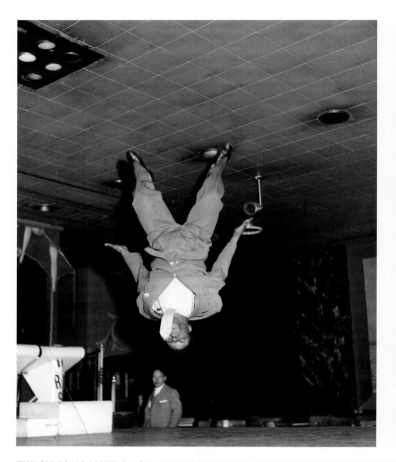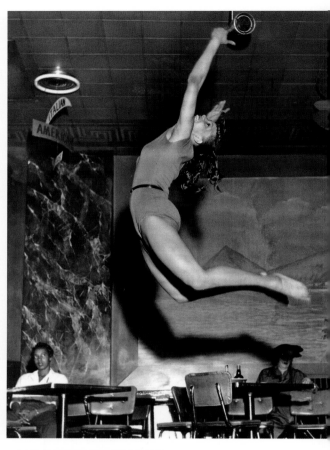

THE SKY'S NO LIMIT ON CLUB DELISA'S STAGE: TWO OF THE ACCOMPLISHED ARTISTES WHO WERE SUREFIRE CROWD PLEASERS.

reveal few people in the audience. Simmons likely took them during daytime rehearsals.

Certain entertainers are provocatively costumed; others, dressed in suits. In one dumbfounding image, an attractive woman sits atop a table. A man has hoisted everything into the air with his teeth. That's right: he has the table edge in his mouth and he is

lifting the table, along with the woman, with his jaw alone.

"Lockjaw" Jackson, from the island of Trinidad, dubbed his act "table eating." In an attention-grabbing photo appearing in a 1962 issue of *Jet* magazine, Jackson lifts a table with his mouth while his six-year-old son, "Lockjaw Jr.," stands atop it. At the same time, Junior apes *his* dad by grasping

his own miniature version in his mouth. A signed but undated ink drawing catches the suavely dressed Jackson in the act. His body seems stupefied as his caricatured oversized head elevates a 50-pound barbell that rests on a tabletop.

Acrobatic and novelty acts were plentiful in the South Side clubs when Lonnie Simmons was in his prime. The Crown Propeller

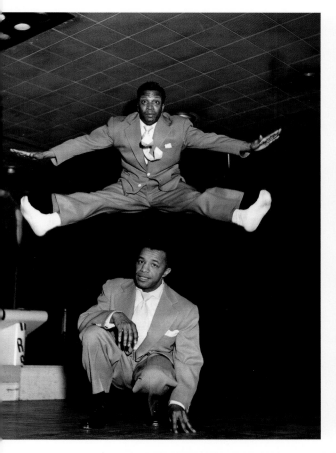

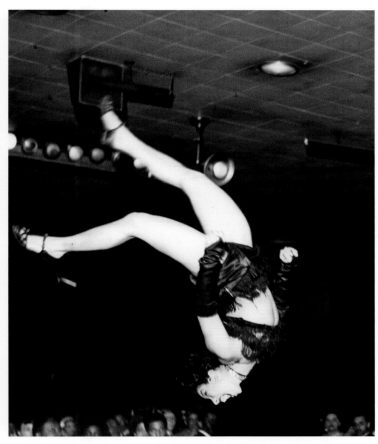

AGILE PERFORMERS KEPT AUDIENCES RAPT WITH REMARKABLE LEAPS, NAIL-BITING FLIPS, IRREPRESSIBLE ENERGY.

Lounge, for example, featured a mermaid in a tank. George Burney and His Flying Feet was able to jump over fifteen chairs. He later became a civil rights activist in Louisville, Kentucky. The aptly named Princess Wee Wee was billed as a "midget entertainer."

Comedy was at the core of the dance and acrobatic team of [Charles] Cook and [Ernest] Brown. They were a built-in sight gag: one standing at six feet tall, and the other four feet ten. Contortionist "Jigsaw" (Brady) Jackson, "the human corkscrew" and self-styled "freak dancer," was known for balancing his body on his chin while he tapped out rhythms in the air. Rope dancers Danny and Edith performed aerial feats while suspended above the audience. And acrobats such as the Wong Sisters, the Three Browns, and Janet Sayre each fashioned their own distinctive strategies to hook onlookers. Smiles of satisfaction commingled with gasps of disbelief from spellbound spectators.

Perhaps the most unusual example of these novelty acts was Henry "Crip" Heard, who lost his arm and leg on the right side

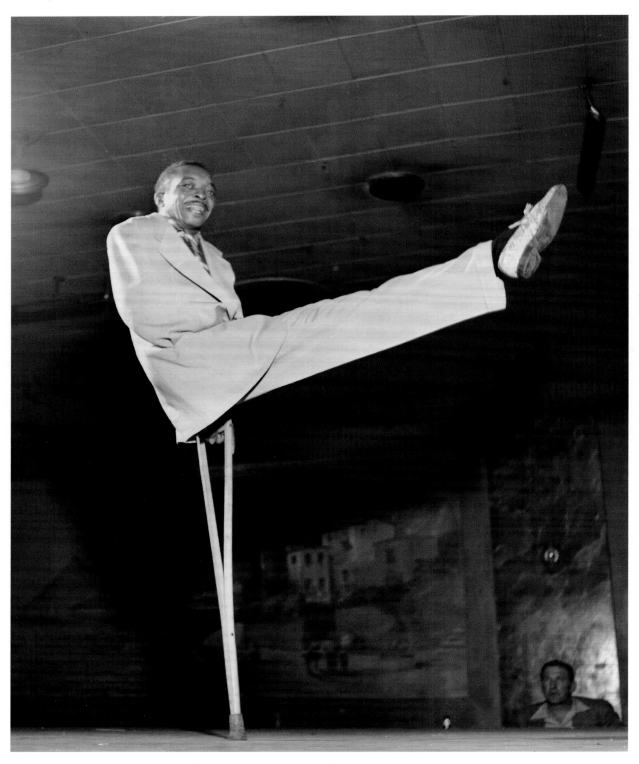

DANCER HENRY "CRIP" HEARD BALANCES ON A CRUTCH, DEFYING GRAVITY.

of his body in an accident as a young man. The still photos shot by Simmons show Heard in action. They were undoubtedly taken in Club DeLisa because the Red Saunders Band is in the background. Heard also starred in the 1948 film *Boarding House Blues* with Moms Mabley. In Heard's nearly three-minute film performance, he bounces, turns, dips, hops, sways, and shimmies on stage. His crutch is as much a prop as an aid to balancing. At times he uses it, at others he tosses it aside. The photos Simmons took of this amazing entertainer provide a tantalizing glimpse of his improbable stage act.

One could easily imagine that Crip Heard was a nonpareil performer. In fact, he was not the only dancer appearing on the South Side at the time who had significant physical challenges. Alfred Duckett wrote in the *Defender* about The Three Leggers, an act that featured two tap dancers, one of whom lost a leg in a car accident. And *Jet* published a photo of Heard alongside Peg Leg

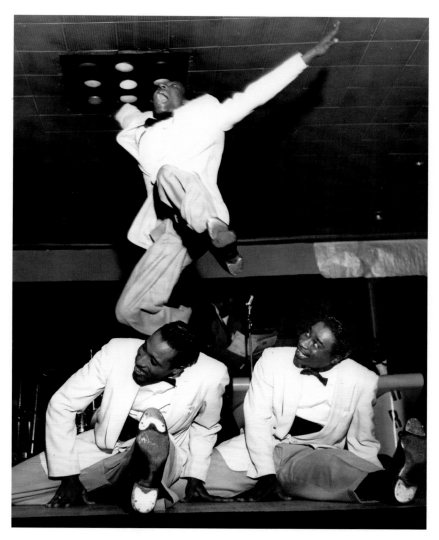

HAT, CANE AND TRAY: DIAMONDS ON THE SOLES OF THEIR SHOES.

Bates, another one-legged entertainer, jumping into the air together ("Aerial flight"). And talk about gimmicks: Milton Weber was a one-armed guitar player who also performed at Club DeLisa.

Song and dance teams likewise proliferated on the Bronzeville entertainment scene: Buck and Bubbles, Dot and Dash, Moke and Poke, Mac and Duke, Chuck and Chuckles, Cholly and Dolly, and Dotie and Charlie. The tap dancing Rimmer Sisters, who appeared on TV's *Ed Sullivan Show,* and the

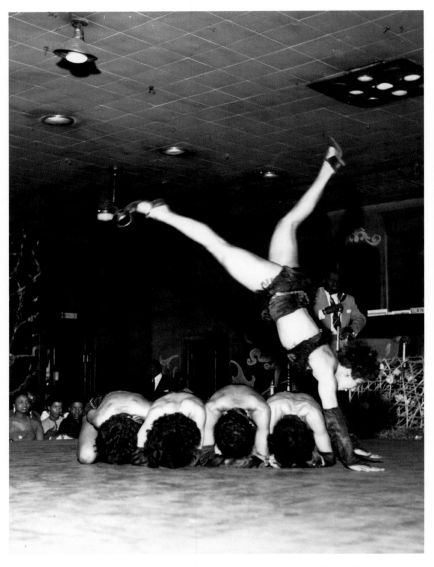

THE DYERETTES, CHOREOGRAPHED BY CLUB DELISA'S SAMMY DYER.

Calloway. Other groups were the Four Kit Kats, the Four Step Brothers, the Four Congaroos, and the Four Dancing Ebonites.

Groups of chorus girls included the Jordanettes, Dyerettes (dubbed the African-American Rockettes), Bensonettes, and Vashonettes. The 12 Beige Beauts and the 10 Zanzi Beauts had similarly evocative names. Dancers at the time mastered a broad range of performance styles: the lindy hop, shake dancing, calypso, and even traditional ballroom.

CHICAGO PERSONALITIES

It is not clear when Simmons took up photography, but there are many indications that he pursued it seriously. We can deduce this from the vast quantity and the accomplished quality of his images. By the frequency with which he is shown pursuing his craft (often leering at his female subjects, sometimes comically so). And by examining the professionally equipped darkroom where he worked.

Edwards Sisters, called by the *Pittsburgh Courier* "one of the fastest dance teams in the business," shared South Side stages with the Berry Brothers and the incomparable Nicholas Brothers.

Tip, Tap and Toe, and Hat, Cane and Tray worked amidst other jazzy-named trios. The Three Rockets. The Three Giants of Rhythm, including Honi Coles. And the Three Chocolateers, a dancing and singing group that performed with Cab

IN FOCUS: STEPPING OUT

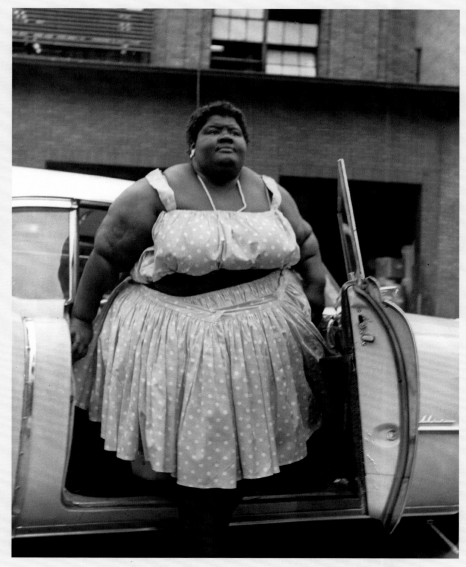

WE MAY NOT KNOW THIS WOMAN'S NAME, BUT HER MOXIE IS IRREPRESSIBLE.

This lady knows how to make an entrance! Her two-piece polka-dotted outfit both covers and reveals. She is not timid about exposing her arms and midriff. It is summer, surely. But her billowing skirt is more modest, reaching her knees. She gazes into the distance, ignoring her immediate environs for the moment. This image has been tightly shot, offering us few external clues. Who is she? Where is she being dropped off? And who drove her in the white sedan?

The photos of women in this archive mostly feature a narrow range of body types. The curvy silhouette that was highly desired at the time is seen in some of the glamorous women on stage; it is also evident in women enjoying themselves as audience members or freshening their makeup. Toned, athletic bodies are represented in the numerous shots of professional dancers or acrobatic performers. But that obviously does not reflect the variety of actual physical appearances.

One reading of this photo is that it is tawdry, mocking, voyeuristic. In other words, this woman has been turned into a spectacle. But it invites an alternate interpretation. When larger-size women such as LaVern Baker (a singer whose early stage name was Little Miss Sharecropper) or Velma Middleton (a vocalist who performed in Louis Armstrong's bands) show up in Simmons' work, they are mildly mocked in humorous eating scenes. But this woman seems to care little about what other people think of her. She is too self-possessed for that. She got dressed up. And she is out for a good time.

Simmons carried a Graflex Speed Graphic, *the* press camera of the era, with a portrait lens on the front. He is also seen with a Rolleiflex medium format twin lens reflex with a grip that allowed him to connect his hand-held flash.

The darkroom that Simmons installed in the basement of his home at 7655 South Wabash Avenue has all the hallmarks of a professional-level operation. His enlarger is top-of-the line. This enabled him to do his own processing rather than rely upon an outside lab. Everything you would expect to see in such a setup is evident in several images: rows of bottles of chemicals, funnels for mixing them, and trays used for the successive stages of the developing process. A dark light has been mounted overhead; sheets of film hang to dry. Outfitted in a darkroom apron, Simmons is obviously showing off in one shot. The height of his "pour" into a tray would not be standard procedure. It provides drama but would likely result in

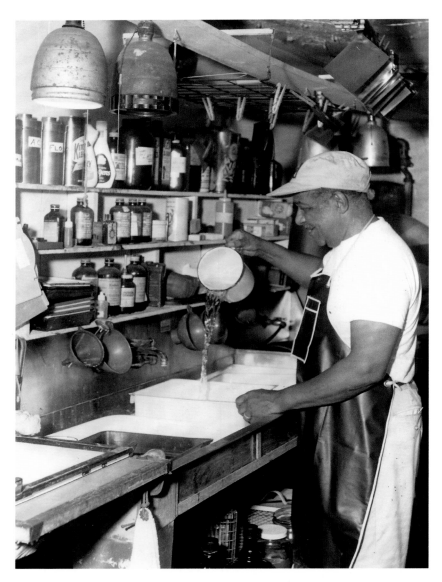

LONNIE SIMMONS IN HIS DARKROOM, ANOTHER ARENA IN WHICH HE EXCELLED.

splashing himself with caustic chemicals. Simmons was too accomplished to commit such a gaffe. But he was not a person to pass up the opportunity to make a lasting impression.

Simmons spent the bulk of his adult life in Chicago. Many of his photographs of local entertainers and personalities have national significance. He also photographed Chicagoans important to the city's political history.

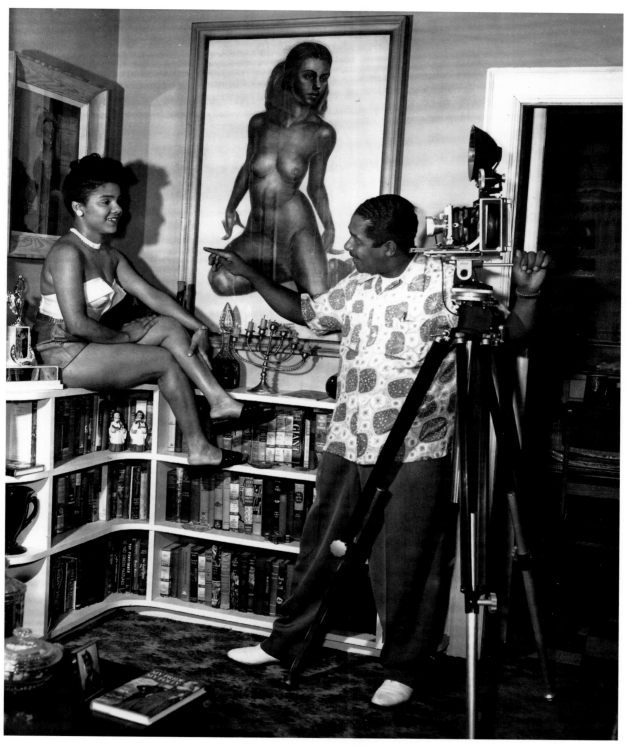

LONNIE SIMMONS PLIES HIS CRAFT IN AN IMPROVISED WORKSPACE AT THE HOME HE SHARED WITH WIFE MARIETTA.

IN FOCUS: A TRANSCENDENT MOMENT

The beloved Chicago DJ Daddy-O Daylie shares the stage with internationally acclaimed singer Billie Holiday in one of the standout photographs of the Simmons archive. Holiday is in her prime. She radiates health and vitality. Her bearing is classy and elegant. Holiday tilts her head to the microphone to project her voice as robustly as possible. She is absorbed in the creative moment. Daylie stands behind her, beaming broadly. He looks to be all limbs and has a boyish appearance. His sense of delight as a spectator is unmistakable. Holiday's body twists toward the mic stand; Daylie's body leans toward her. He is gleefully caught in the orbit of this star.

Billie Holiday, like Lonnie Simmons, was discovered by legendary scout John Hammond Sr. They performed at some of the same venues (including New York's Savoy Ballroom) and they both enjoyed close relationships with Ella Fitzgerald and Louis Armstrong. Daylie enlisted Holiday to participate in a benefit at the Hines V.A. Hospital, outside Chicago, according to Dempsey Travis' *An Autobiography of Black Jazz.* This photo captures a singular moment of that concert.

Lady Day's turbulent upbringing and her struggles with drugs, alcohol, and abusive men have been well documented. But this photo is pure performance, pure rapture. The immediacy of the image allows viewers to feel almost as if they are witnessing the show first hand. Any photographer would be proud to have captured the dynamics of the scene with such richness and vividness.

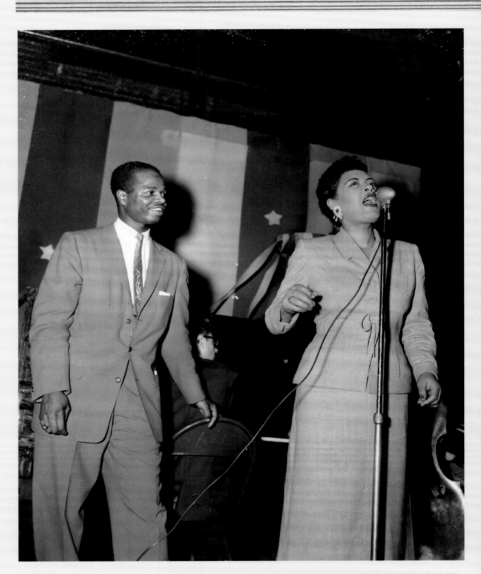

DADDY-O DAYLIE AND BILLIE HOLIDAY: TWO DYNAMIC ENTERTAINERS ON ONE STAGE.

One notable Chicagoan was DJ/radio personality Holmes Daylie, who had the coolest moniker. Known publicly as Daddy-O Daylie, he began his career as a bartender. Daylie gathered a large following when he worked at the DuSable Lounge. He was also employed at the Pershing Hotel's El Grotto Supper Club and Beige Room. These jobs positioned him to meet and befriend some of the jazz world's greats. The pioneering broadcaster Dave Garroway planted the idea in Daylie's mind that he should command a larger audience. Daylie subsequently moved to radio, where his outsized personality enthralled audiences for well over three decades. He was celebrated for an improvisational and rhythmic announcing style that complemented the jazz he played on air.

Ken Blewitt was the manager of the elegantly appointed Regal Theater, which opened in 1928 and operated until 1973. It was a local outpost of the Chitlin' Circuit, along with Club DeLisa and Roberts Show Lounge. These places relied upon agents to book African-American performers who offered a broad range of acts, from vaudeville to blues. The Regal was Chicago's version

JACK L. COOPER WAS A PIONEER ON CHICAGO RADIO.

LOCAL GUYS MAKE GOOD: THE RAMSEY LEWIS TRIO.

of Harlem's Apollo Theater. Black employees occupied roles from management to maintenance. Every major Black jazz, blues, and pop act found its way to the Regal's stage. Stevie Wonder's breakthrough track "Fingertips" was recorded there, as were live albums by Gene "The Duke of Earl" Chandler and B.B. King.

Jack L. Cooper is credited with being the first Black disk jockey. He hosted The All-Negro Hour on radio from 1929 to 1936, with a mix of guests who mirrored his own career as a vaudeville performer. Lou Breese was a Chicago-based musician and conductor who performed in all major Chicago theaters. Lonnie Simmons was once a member of his orchestra.

Model Janet Langhart, selected to be Miss Chicagoland in 1967, subsequently became the first Black "weather girl" on two Chicago TV stations. She was later a host, producer, commentator, and reporter on the Black Entertainment Television network, and for stations in Boston and New York City.

The jazz scene in Chicago lured Maxine Johnson from the tiny town of Gibson City, Illinois. Along with her musician husband Franz Jackson, this singer performed locally and internationally. Johnson also portrayed the fictional character of Aunt Jemima during the 1960s and '70s. Once her career in entertainment waned, she returned to her hometown and became a nurse.

Pianist and composer Ramsey Lewis Jr., performing solo and with his Ramsey Lewis Trio, achieved fame beyond Chicago with such hits as "The In Crowd," "Hang on Sloopy," and "Wade in the Water." Oscar Brown Jr. is primarily remembered as a singer-songwriter, actor, and civil rights activist.

On the political front, Simmons is pictured with Illinois Comptroller Roland W. Burris, who years later was appointed to replace Barack Obama in the U.S. Senate, and with Richard J. Daley, who was mayor of Chicago from 1955 until his death in 1976.

DRESSING UP IN ANOTHER FASHION

Recent LGBTQ historiography has unearthed another dimension of the African-American South Side: a thriving, openly gay subculture. "From Bronzeville's earliest days," writes Jim Elledge in *The Boys of Fairy Town,* "queer men had been part and parcel of the neighborhood and found acceptance among its vast array of entertainers." Scholar Tristan Cabello has designated Club DeLisa and the Cabin Inn the "most popular gay cabarets."

Gay people populated both Bronzeville's audiences and stages. The star of the Cabin Inn was "the Brown Mae West . . . not to be confused with the Sepia Mae West," according to Cabello. Also popular in the South Side clubs were the Sepia Joan Crawford and the Sepia Gloria Swanson. A reform-minded mayor cracked down on the Cabin Inn, and it eventually closed. Police struck Club DeLisa as well, forcing female impersonator Peggy

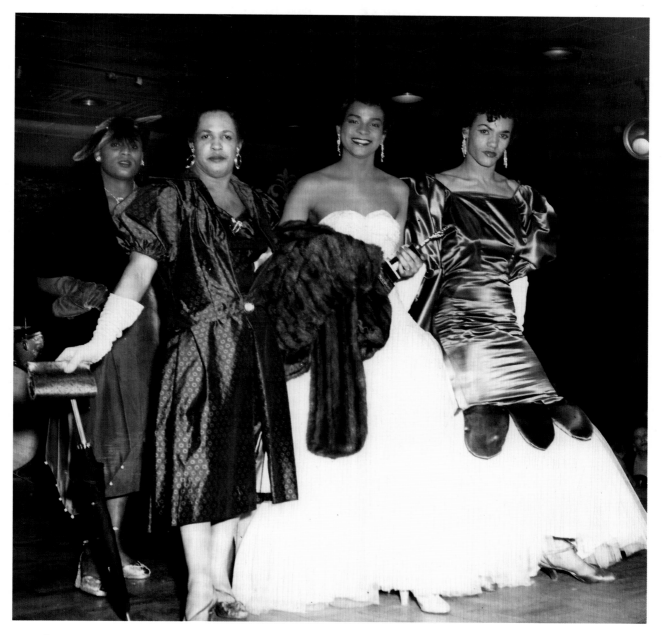

FOUR VOGUEISH DRAG QUEENS COMPETE FOR A TROPHY ON THE CLUB DELISA STAGE, DELIGHTING THE AUDIENCE.

Hopkins Joyce to stop performing there.

Simmons was one of two photographers who produced a lavish and provocative six-page brochure for the New Jewel Box Revue, once the country's preeminent touring female impersonator show. Highlights include a dressing room view of men in various stages of dress and undress, applying their stage makeup. A panoramic

view of the performers in extravagant gowns. And candid shots, including two taken with Sammy Davis Jr. In one instance, Davis relaxes with a man named Lynne Carter. In a companion photo, Carter has transformed himself into a sultry beauty. The Revue played the Roberts Show Lounge, later a Simmons haunt, in 1957; it was also booked at the popular Regal Theater.

Drag queens appear in several photos in the Simmons oeuvre. In one instance, one of the DeLisa brothers awards a trophy to an elated young man wearing a billowing white strapless gown with fitted bodice. The same man also poses with three other men dressed as women. This time, a fur has been casually draped over one arm, while the other hand clutches that cherished trophy. Their accessories for an elegant evening out included dangle earrings, long gloves, and a broad-brimmed hat. In another scenario, a heavily made-up African-American man in an elaborate form-fitting brocade dress teasingly

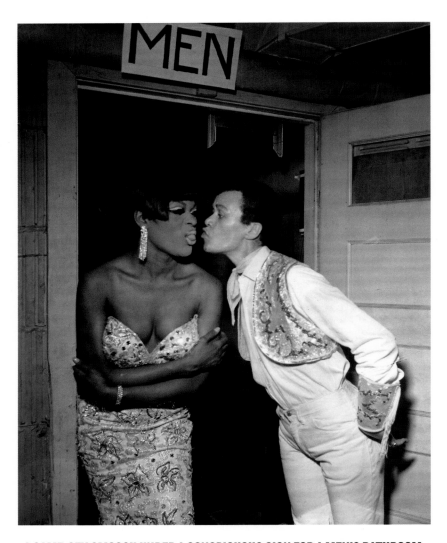

A SAME-SEX SMOOCH UNDER A CONSPICUOUS SIGN FOR A MEN'S BATHROOM.

offers a kiss to another man. The target of his affection is attired in a matador's costume.

Simmons also photographed a pair of men who lightheartedly share a mock kiss. One of them is easily recognized. He is comedian Redd Foxx, who got his professional start in Chicago's nightclubs and theaters. Foxx later became a television sit-com star as the feckless and acerbic junk dealer Fred G. Sanford in *Sanford and Son*. His collaborator in the scene caught by Simmons is comedian Slappy White.

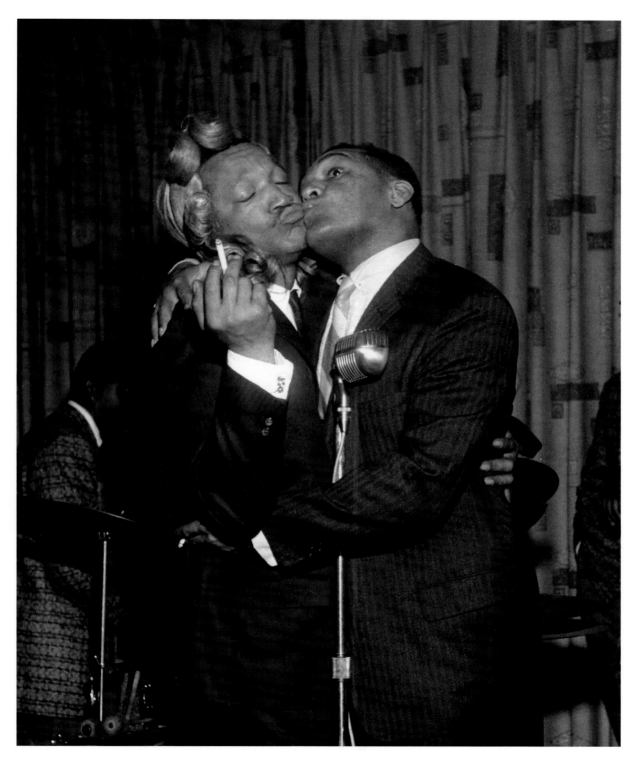

CHITLIN' CIRCUIT MAINSTAYS, COMEDIANS REDD FOXX AND SLAPPY WHITE, CAMP IT UP.

WORKING THE POLICE BEAT

New Yorker Arthur Fellig, aka Weegee, is renowned as a rough-and-tumble American street photographer. He was cigar-smoking and streetwise. Armed with his Speed Graphic and hand-held flash, Weegee's métier was catching people at moments of crisis. Crime victims and suicides were his stock in trade. As surprising as it may sound, Simmons cultivated similar ground.

Images credited to Simmons regularly appeared throughout the 1950s and '60s in the *Chicago Defender,* whose audience and influence extended far beyond its home base. Early credits listed Simmons as a "Defender reader." His relationship became more formalized over time, after which tags such as "Photo for Defender," and occasionally "Photo by L.S.," predominated.

Simmons also freelanced for *Jet* and *Ebony,* and his work appeared in other African-American publications as well.

WEATHER
COOLER, RAIN
High 54
Low 34

DAILY DEFENDER

Chicago's Picture Newspaper

5c

VOL. II—No. 31 ★★ CHICAGO, ILLINOIS—MONDAY, APRIL 1, 1957 WANT ADS: Call CA. 5-5656

RUSS SAY U. S. PLOTS 'A-WAR'

(See Page 3)

1 Slain, 3 Shot As Lovers Spat

(See Page 1)

Starting 'Em Young

THIS PHOTO shows a young warrior of Red China, complete with his machine gun. It was made by a Look magazine photographer who is the first American to visit China since the Communists came to power. The pint-sized "soldier" was shy when confronted by a foreigner with a camera. INP Soundphoto

← **Meets Death Face To Face**

MRS. FLORA CASEY, 3813 Giles ave., stares in horror at body of her husband, Roy, 41 who was killed in a gun duel Sunday morning in an apartment at 4927 South Parkway. Police say Smiley Turner fatally shot Casey as Casey approached him with a gun after Turner had beaten his girlfriend and shot two other persons. See story, other pictures, page 3. Defender photo by Lonnie Simmons

Dr. Charles M. Thompson Rites Tues. See Page 4

LONNIE SIMMONS COVERED CORE TABLOID THEMES: CRIME, ACCIDENTS, AND DISASTERS

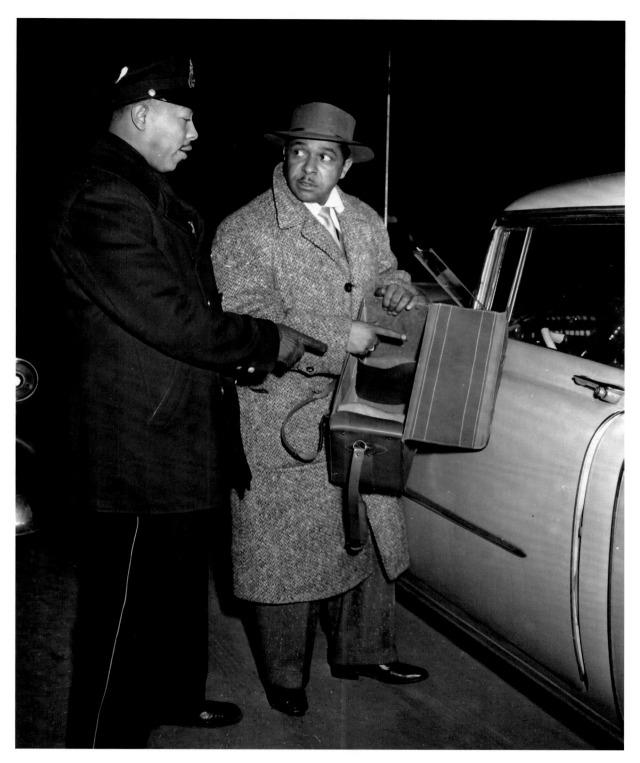

A BROKEN WINDOW AND EMPTY CAMERA BAG: LONNIE SIMMONS IS HIMSELF A CRIME VICTIM.

THE DEFENDER REGULARLY FEATURED PHOTOGRAPHS LONNIE SIMMONS SNAPPED OF PEOPLE IN EXTREME SITUATIONS.

Simmons reportedly dashed off the stage or sneaked out between sets to shoot an unfolding crime scene. "While working at the Club DeLisa, I'd go out and shoot accident, suicide and rape victims," the *Chicago Sun-Times'* Hoekstra reported. *Sepia* magazine profiled Simmons in 1955 in an article titled "The man who never sleeps—Chicago nitery organist makes crime photography his hobby." The pages of the *Chicago*

Defender, Jet, and *Ebony* were filled with rough, half-toned reproductions of Simmons' work from 1952 to 1963. His images accompanied newsflashes with sensational headlines:

"Wife sees mate shot to death at police station"

"Chicagoan kills self kissing murdered mate"

"Bites off wife's nose during rage"

His photos portray a brutal world of knife fights, gambling-bets-gone-wrong,

service station robberies (one for 65 cents), marijuana busts, and shooting sprees. "That's him," says a subject of one of Simmons' photos as he points an accusing finger. In another, a woman stares at the body of her husband, killed in a South Parkway gun duel. The page one headline: "Meets death face to face."

A common motif was heavy drinking that sparked a man's deadly rage. Romantic triangles were also regularly

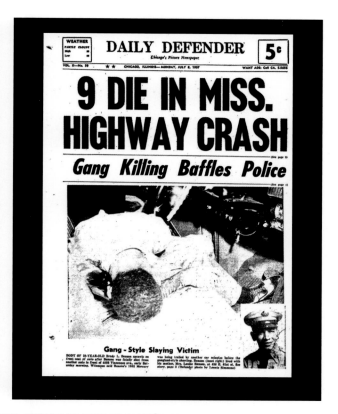

THE CHICAGO DEFENDER SERVED AFRICAN-AMERICAN READERS NATIONWIDE.

recounted. Mistresses could be as young as 16 years old. In general, a jilted wife killed the philandering husband.

Nevertheless, in one instance, the body of a woman who was killed by her boyfriend is shown sprawled across the kitchen linoleum. In another, a woman's corpse lies on the ground, arms and legs akimbo. She had been shot by her common-law husband. One of the most dramatic scenes Simmons captured was the aftermath of a murder-suicide, where a dead man clutches his dead wife in "a grotesque death embrace." His shirt is drenched in the blood of the woman he had shot and killed moments before he took his own life.

Simmons captured emotions ranging from anger to desperation to resignation. In some instances, people had to be restrained from committing more violence as he arrived on the scene. In others, they were held up by other people to prevent a physical collapse.

Simmons occasionally became part of the story. An article from 1954 titled "Photographer helps cops nab robbers; loses proof" relates how Simmons witnessed a break-in and notified the cops. Simmons later accidentally exposed the film that would have validated his own role in apprehending the criminals. Another time, Simmons came upon a woman with a

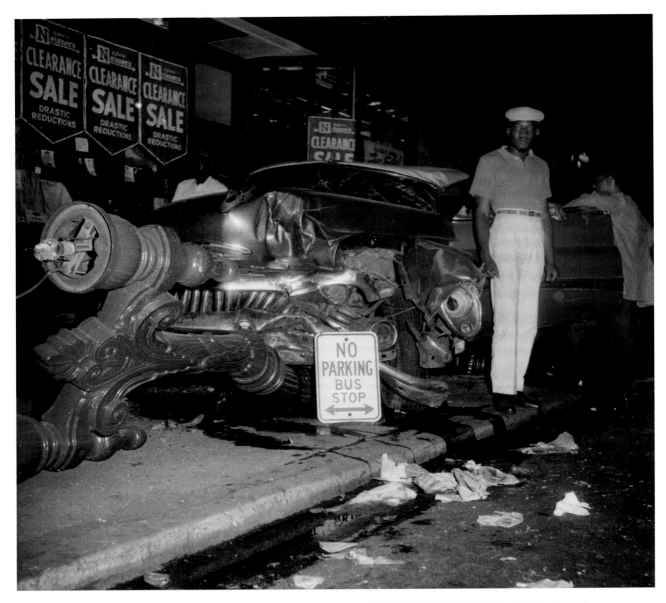

LONNIE SIMMONS WAS ON THE SCENE TO CAPTURE THE WRECKAGE OF A SPECTACULAR SMASHUP.

slashed wrist. Responding quickly, he cleverly fashioned a tourniquet from his scarf and a fly swatter. He called the police, and then got his scoop. That *Defender* story from 1958 led with

"Rescued, then shot."

Simmons recorded other moments of crisis as well. A family of four watches its home burn, as if they are viewing a horror movie. The victim of a roof cave-in lies

inert on a medical examining table. And a young traffic accident victim rests on a police stretcher. He's bewildered, in shock.

Beyond the obvious evidentiary value of his

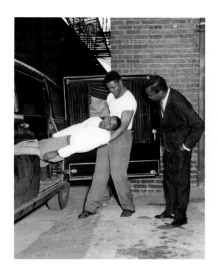

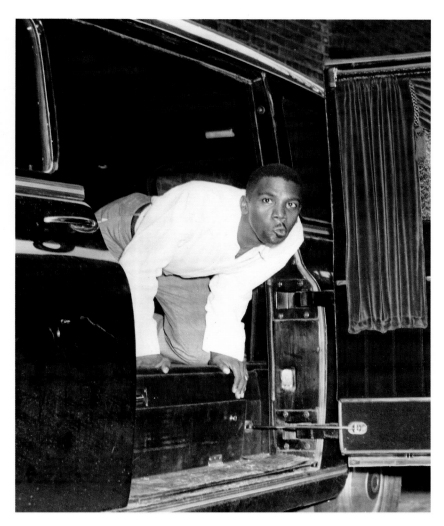

BUT SURPRISE! A "CORPSE" IS UNEXPECTEDLY RESURRECTED.

photos, Simmons' activities often intersected with the police and the criminal world. He sometimes rode with Chicago police and casually hung around the Wabash Avenue Station. Officers even attended one of his birthday bashes. When Simmons entertained inmates at the Cook County Jail, his deeds earned him honorary membership in the Chicago Patrolman's Association.

This archive contains one photo taken by Simmons that without question documents a crime scene. It shows the prone body of a beautiful young woman lying on a sidewalk. A police officer and a man in civilian clothes stare intently at the corpse. Her blouse and skirt have been hiked up. She is evidently the victim of a violent sexual assault. It is doubtful that any publication would have run such an explicit picture.

A photo of a man who has obviously taken a beating very likely records another instance of crime. But because we cannot discern much from the background setting, it is not possible to validate this claim for certain. Moreover, Simmons loved joking around. He appears to mock his own sideline in a two-shot sequence. In the first, a man winces as he slides the rigid body of another into the rear of a hearse. A man in

a suit watches intently. The "resurrected" victim leans out of the vehicle in the next frame, an exaggerated smirk on his face. It is one of the many sight gags that Simmons recorded.

Two shots of the aftermath of an automobile accident provide a further example of Simmons' vivid on-the-scene reporting. One shows a man pressing a makeshift ice bag to his forehead; the other, the mangled wreck and a downed street lamp.

CREATING ILLUSIONS

Photo historian Jim Linderman credits Simmons as one of the unsung heroes of photography on his blog "Dull Tool Dim Bulb." He speculates that Simmons worked as an in-house photographer producing souvenir folders for the patrons of Club DeLisa. "Table shots" were a common practice in many clubs, lounges, and restaurants during this era. Customers could have their photos taken as a memento of a pleasurable night out.* By the end of the evening, their photo had been processed and mounted in a

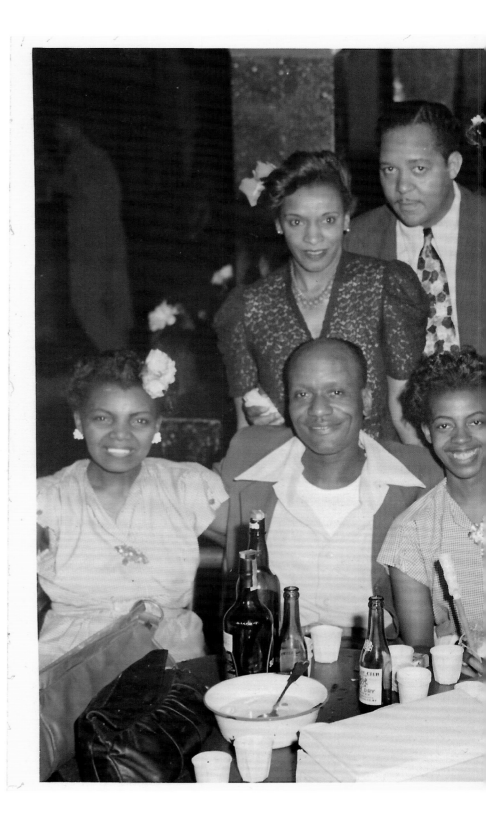

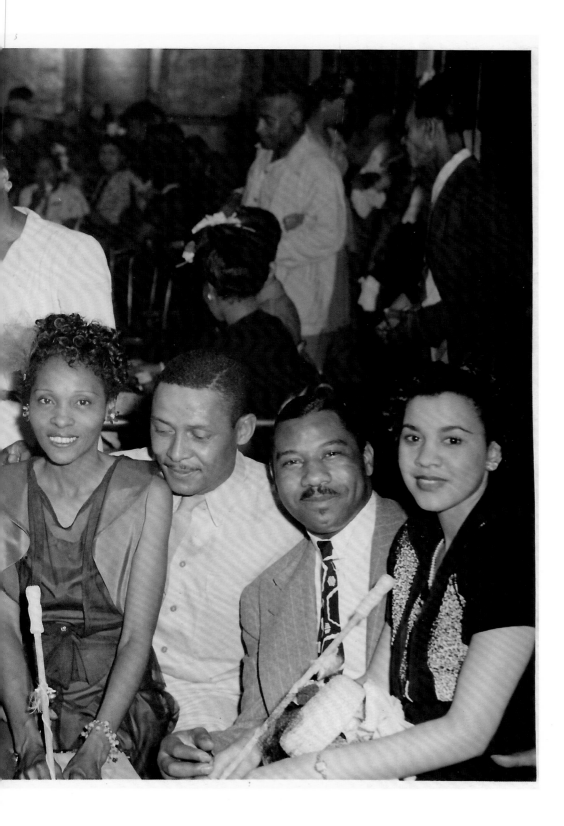

*This photo and the ones on the following two pages are table shots that were separated from their Club DeLisa folders. Photographs such as these do not carry credits to whomever produced them.

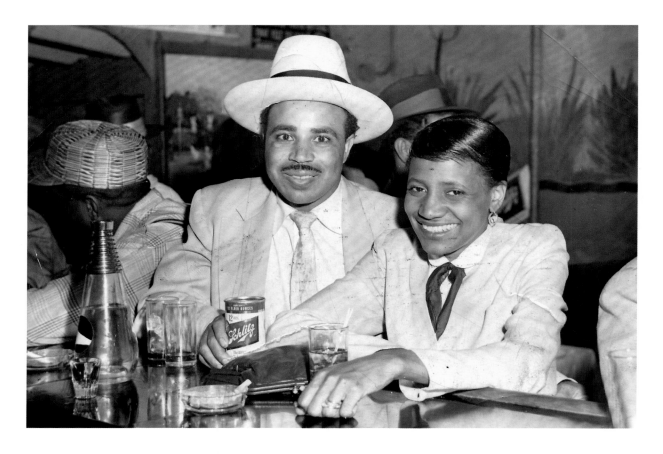

NIGHTCLUB DENIZENS WEAR BROAD SMILES AND SHARP FASHIONS.

cardboard holder bearing the club's name and logo.

Simmons wore a number of different professional hats. He was a man of unusual energy. Nonetheless, could he have managed the picture taking and entire production process of creating nightclub mementoes *and* fulfilled his musical responsibilities? It seems unlikely.

Simmons occasionally played a trickster role in his photographic practice. In one series of photographs,

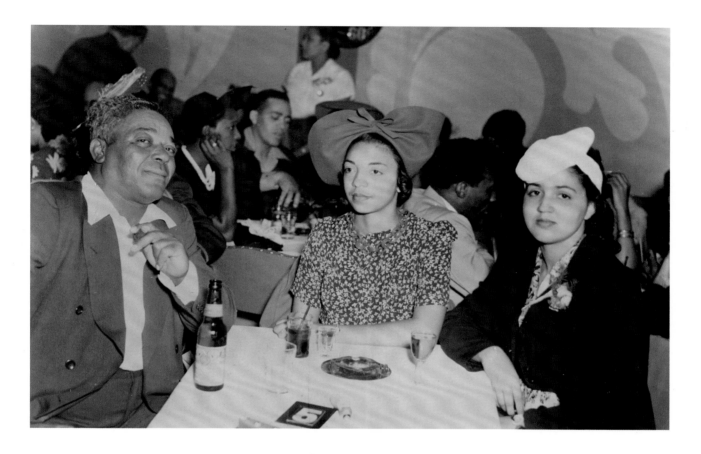

he shoots a nude, alabaster-skinned woman and then molds her into a cocktail glass. One part of the sequence resembles a rudimentary version of the high-tech green screen movie industry trick. In another instance it appears as if Simmons constructed an alluring portrait of three dancers at Club DeLisa. These women are perfectly synchronized and look identical. It indeed appears as if he magnified a specific lone performer into an ensemble.

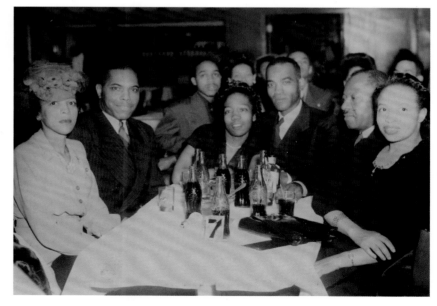

"TABLE SHOTS" PROVIDED MEMORIES OF AN ENJOYABLE NIGHT OUT.

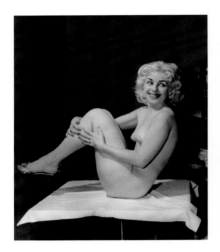

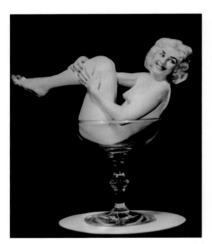

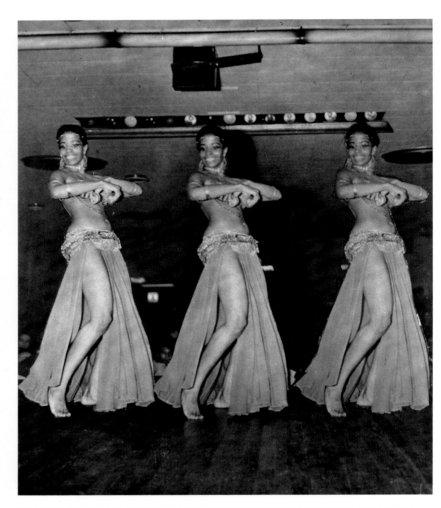

LONNIE SIMMONS ACQUIRED A BROAD RANGE OF PHOTOGRAPHY SKILLS THAT PARALLELED HIS MUSICAL EXPERTISE.

However, if you examine the background you can see the uninterrupted row of theatrical lights overhead. It is also possible to glimpse different members of the audience between the performers. Simmons would have had to perfectly match the alignment of the floorboards to construct this image. The shot may very well be the real deal, a rare rhythmic moment frozen in time.

KING LOUIS ON HIS THRONE

Louis Armstrong appears in at least seventeen photos in the Simmons archive. That's more than any other entertainer. Sammy Davis Jr. holds second place with about half that many. A series of four shots featuring Armstrong provides a glimpse into Simmons' working methods. And reveals a rowdy yet warm relationship between the men.

Two of the photos catch Armstrong in the bathroom, seated on a porcelain throne. His pants are pushed halfway down his thighs and

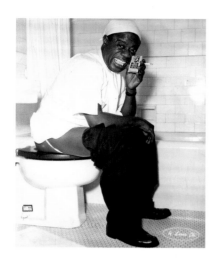

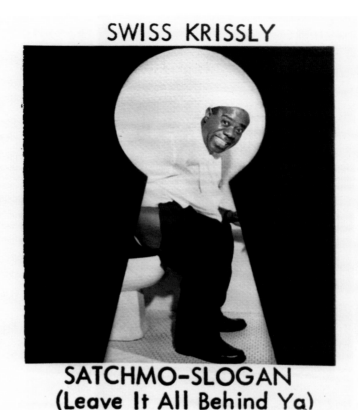

SWISS KRISSLY

SATCHMO-SLOGAN
(Leave It All Behind Ya)

LOUIS ARMSTRONG COMICALLY ENDORSES HIS LAXATIVE OF CHOICE.

he displays an enormous smile. His right hand holds a cigarette and a cigarette-sized box. But it is not a pack of smokes. Armstrong is endorsing a powdered natural herb laxative, Swiss Kriss. Armstrong proclaimed that he depended upon this product to stay "regular" and to lose weight. He was such a devotee that he reportedly gave a box to the Royal Family at Buckingham Palace.

The other pair of images demonstrates how Lonnie Simmons used a composite process to construct a product promotion. Simmons first placed an enlarged cutout of the keyhole of a door over a negative of his photo of Armstrong. He then created a positive

from the combination. The finished product positions the audience as voyeurs, supposedly spying on a celebrity during a private moment. Running along the bottom margin is the slogan "Leave It All Behind Ya."

Armstrong became the unofficial celebrity spokesman for Swiss Kriss. He even repurposed this design on his Christmas cards. In the auction where

the Simmons archive was sold in 2018, several related pieces of this material were separated to comprise an additional lot. The most notable item is a copy of the photo of Armstrong on the toilet that he personally inscribed to Simmons: "To Lonnie Simmons/Man you can Snap your 'Ars Off'/ no shit/Louis Boy/Louis Armstrong/Satchmo." It's hard to imagine a more rousing endorsement.

A BLACK CAT IN A WHITE JOINT

A significant shift in the sort of people who surrounded Simmons is evident in this collection. Early on, chic African-American women hang on his arm and fawn over him. They often sport flashy showgirl costumes or are turned out in elegant evening wear. Simmons keeps an abundance of glamorous celebrities in tow as well.

Later in his career, when he was an entertainer beyond Bronzeville, he is typically pictured with patrons and fans dressed in casual street clothes. Moreover, they are invariably white folks. This is the world that Simmons inhabited during the remainder of his professional career.

The buzzy South Side scene that Simmons once moved through so easily collapsed in the late 1950s and '60s. Its demise was triggered by a number of factors. Some were calculated, others unanticipated. Post-war, Chicago's Black Belt was expanding slightly, and was physically deteriorating.

Various constituencies looked on, horror-struck. That included downtown businessmen, politicians, and prominent South Side institutions such as Michael Reese Hospital and the Illinois Institute of Technology.

The decline of the area was partially due to larger economic developments. Basic manual skills were once sufficient for many of the people arriving as part of the Great Migration to secure a job. But no longer. The country was tilting from blue collar to white collar; the dominance of the manufacturing sector was giving way to the service professions. Jobs that were once plentiful, providing a likely pathway to a solid working- or middle-class life, were dwindling. The volume of work in Chicago's Union Stockyards started to decline in the 1950s, for example, as the industry decentralized. (The Stockyards closed in 1971.) Fewer people pulled down salaries that could bankroll nights on the town.

Driven by the upbeat rhetoric of urban renewal that seized the imaginations of city planners nationwide, the city of Chicago displaced tens of thousands of African Americans from their South Side homes. Part of the cleared land was used to build the privately funded modernist apartment complexes Lake Meadows (completed in 1960) and Prairie Shores (1961), which offered airy high-rise comfort to a racially integrated middle-class clientele. These developments also provided a buffer from inner-city realities for the nearby hospital and university. A shot of the marquee of the Lake Meadows Shopping Center advertises Simmons appearing at the Lake Meadows Restaurant, demonstrating how he adapted to the changing realities of the neighborhood.

As music historian Charles Sengstock noted in 1959, "Every day at Tech Center [IIT] old buildings disappear. . . . Just last month, the historic Grand Theatre was torn down." As the redevelopment impulse gained momentum, "one by one, the cafes and clubs began to disappear." He noted that a popular jazz

spot, Dusty Bottoms, was gone. The Deluxe Cafe and the Panama Café as well. The Mecca Apartments, which housed 2,000 people and was immortalized in the song "Mecca Flat Blues," was also bulldozed to make way for the expanding IIT campus. Distressingly similar scenarios unfolded with regard to the destruction of the African-American nightclub districts of Detroit's Paradise Valley and San Francisco's Fillmore neighborhood.

The massive concrete bunkers of Chicago's Robert Taylor Homes began a steady march up the State Street corridor. By 1962, some 28 buildings loomed over a largely razed streetscape, along with additional public housing projects. (This is now history: the last of the Robert Taylor Homes was demolished in 2007.)

Ironically, the victories of the Civil Rights Movement also played a role in the demise of the lively entertainment scene on the South Side. Before the 1960s, restrictive housing covenants buttressed by racist social norms confined African Americans within particular geographic areas. As a result, African Americans of all classes lived in close proximity. A dense network of Black-owned businesses and services flourished.

The DuSable Hotel was an African-American landmark where Simmons once lived and worked. It is a prime example of an African-American amenity that flourished in the pre-Civil Rights era and declined afterwards. When African-American entertainers were not permitted to stay in downtown hotels, they congregated in this one place, generating a festive and creative vibe.

But with the expanded opportunities brought by Civil Rights victories, African Americans enjoyed greater freedoms. They could look outside their communities for places to live, shop, relax. Bronzeville's population dropped precipitously, leaving a disproportionate number of the young and the elderly. Those in their prime working years, the people most likely to join in the nightlife, became increasingly scarce. The vibrancy of the social life in Bronzeville steadily drained away.

A thesis written about the DuSable Hotel in 1980 forecast the gentrification that gained speed in some South Side neighborhoods a few decades later. These are the same areas that had once been condemned as slums. Author Gloria Coleman argued, "Blacks have the prime land in Chicago and now the whites intend to get it back. The trend is changing. They're moving us on out . . . and the whites are going to be here in town."

At the same time that landmarks were falling, a major change was being felt throughout the ranks of professional musicians. Live performance, and the venues that presented it, grew until mid-century. However, recorded music dramatically rose in popularity, beginning in the 1930s and intensifying as the decades passed. Careers were increasingly made in the studio rather than on stage. Musicians shifted their attention accordingly. Performance became ancillary to record production and radio play.

A *Defender* headline in

1947 declared, "Cocktail bars replace cabarets in many cities." Already, many of the largest and most popular clubs had closed. *Defender* columnist David W. Kellum noted the trend in 1940: "Taverns and liquor stores installed the music machines [i.e., jukeboxes] and it wasn't long before lovers of wine, beer, and whiskey were deserting the nightclubs and enjoying their drinks at the cheaper places." Moreover, jazz became a genre to listen to rather than a type of dance music. Experimental forms became more popular, and other varieties of expression, such as rhythm and blues, developed larger fan bases. In addition, the widespread appeal of television kept people at home, rather than out on the town.

PLAYING ON

Lonnie Simmons' father, Peter, passed away at age 99 in 1955. Simmons returned home to South Carolina to help his family and he brought his mother, Emily, back to Chicago. She lived with her son until she died in 1957.

It was around this time that Simmons married Marietta Finley. The affection with which she is presented in her husband's photos testifies to the strength of their bond. A signature photograph in the Simmons archive highlights Lonnie and Marietta. The couple is radiant. She looks fetching in her full-length fur. He's dashing in his tweed overcoat. His professional photographic equipment is at the ready.

Another version of the pair appears in a hand-drawn Christmas greeting. Marietta is caricatured as a beatnik chick in a skin-tight black halter catsuit, holding a potted sansevieria plant. A fish-eyed, broadly grinning Lonnie aims his camera while gripping the hand-held flash above his head. They have chosen a keyboard, a saxophone, a police cruiser, and a nude pinup to represent their lives. Or *his,* to be precise.

The Simmons couple ooze elegance and merriment, peppered with a wicked sense of self-parody.

They had no children and were well-known figures in Bronzeville, so much so that their birthdays were accorded lavish coverage several times in the *Defender.*

Lonnie and Marietta of course age as you survey the archive. This is particularly apparent through a series of photographic Christmas cards that Simmons produced. Viewing them as a group is like watching a time-lapse photo sequence.

There is a conspicuous absence in his body of work: Simmons is never shown drinking. This is remarkable, given the settings in which he spent so much of his time. What appears to be an exception is one year's family Christmas card where Lonnie is shown pouring Marietta some celebratory champagne. But the glass is empty; the bottle remains uncorked!

Bottles of beer, hard liquor or cocktail glasses show up in this collection, to be sure, but no one actively imbibes. A single image strongly hints at alcoholic revelry. It features Sammy Davis Jr. holding court at a tabletop cluttered with cigarettes, drinks, sunglasses,

LONNIE AND MARIETTA SIMMONS CHICLY DRESSED FOR AN EVENING OUT. HIS CAMERA WAS NEVER FAR FROM REACH.

Lonnie and Marietta

THE PAIR SPOOF THEMSELVES ON A HAND-DRAWN CHRISTMAS GREETING.

and wooden table knockers. (Table knockers were a popular nightclub novelty. Patrons used them to applaud performers or to get the attention of a waitress.) With physical jousting between Davis, Simmons, and Red Saunders, the scene genuinely looks like a party.

Simmons announced to the *Defender's* Rob Roy in 1957 that he was giving up the music profession for "more lucrative work: photography." This had

become a serious pursuit for Simmons. He carried two cameras, a Speed Graphic press camera and a medium-format camera. He installed a darkroom in his South Side home and at one time considered starting a news-photo service.

But Simmons did not, in fact, abandon his music career. He supplemented his regular gig at Club DeLisa by taking advantage of opportunities at other venues between 1956 and 1958. He

played solo on his electric organ at Stelzers' Restaurant and Lounge, at 35th and South Parkway, for example. Simmons and his orchestra also backed Larry Steele's extravaganza "Smart Affairs" at the Regal Theater and at Roberts Show Lounge.

Simmons increasingly diversified his activities in order to make a living. He partnered with his friend Charlie Cole to buy and operate the Morris' Eat Shop in 1959, a Chicago

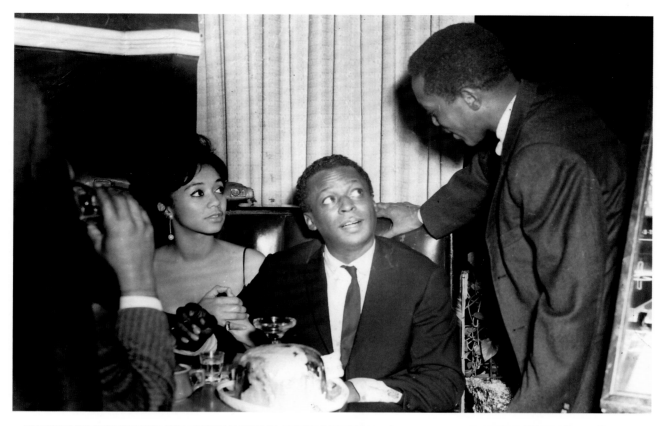

NEWLYWEDS MILES DAVIS AND FRANCES TAYLOR AT THE SOUTH PARK STEAK HOUSE, CO-OWNED BY LONNIE SIMMONS.

landmark also known as the Morris' Perfect Eat Shop. It was where many local and visiting celebrities dined out. According to business cards in the Simmons archive, the place was renamed South Park Steak House, with him listed as president. In between schmoozing with his guests at dinner, Simmons performed on his organ as well.

Quite a few photographs in this collection depict groups of people eating together. A group of these catch people playfully feeding or teasing one another with food. It is clear that these scenes took place at this restaurant because the photos display the distinctive basket weave decorative wall accents, installed in a manner similar to wainscoting. This can also be seen in period postcards and other photos taken at the time. According to Federal Writers' Project participant Grace Outlaw, "The modernistic scheme in furnishings and decorating is very unique. The food is excellent, and the place is immaculately kept. It is by far the most popular eating place on the South Side."

Nightclub gigs were drying up on the South Side in the early 1960s. Simmons played for business and professional clubs, at fashion shows, galas, scholarship dinners, and weddings. During his first two decades in Chicago, Simmons performed at the Loop's Garrick Theatre Bar and

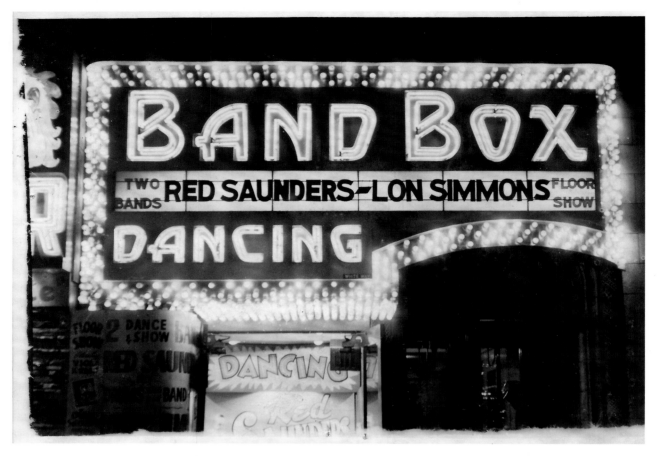

BAND BOX, IN CHICAGO'S LOOP, HOSTED LONNIE SIMMONS AND RED SAUNDERS WHILE SEGREGATION WAS THE NORM.

the Band Box Club, as well as a few times on Chicago's North Side. Local musicians' unions had been segregated; their rules restricted Black performers to the South Side and whites to the North Side or the Loop. But those restrictions were softening by the 1960s, and in 1966 the locals merged.

Simmons subsequently played at Chicago's Edgewater Beach Hotel, a once-luxurious resort on Lake Michigan on the North Side. After it closed in 1967, he moved to Biasetti's Steak House, a neighborhood bar and restaurant at 1625 West Irving Park Road, also on the North Side. What was supposed to be a two-week engagement stretched into 27 years.

Simmons became a popular figure to newspaper reporters, TV hosts, and the predominantly white crowd that frequented Biasetti's. When he played the Hammond X–66 organ, an instrument favored for both its sharp design and the quality of sound it produced, it seemed like Simmons was a band leader once again. Simmons often began each set singing gag songs. Once he warmed up, he might play "Satin Doll" or "What a Wonderful World," and

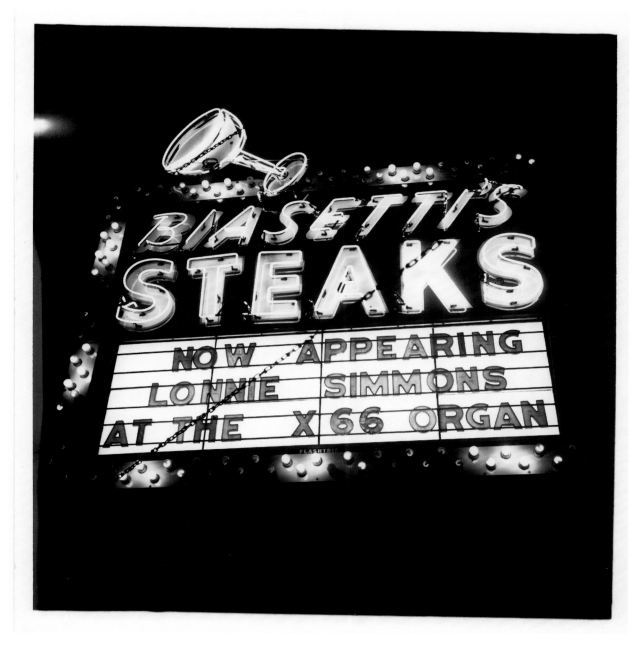

BIASETTI'S STEAK HOUSE ON THE NORTH SIDE, LONNIE SIMMONS' MUSICAL HOME FROM 1967 UNTIL HIS DEATH.

the crowd understood that this was no ordinary lounge singer. His supply of songs was vast. But it did not include any Barry Manilow or rap music, Simmons told Barnaby Dinges of the *Chicago Reader* in 1991. "All you have is a drum and anything that rhymes," Simmons declared. "There's no music there. The dancing part I like. But recitation is not music."

Simmons further

IN FOCUS: A BEAUTIFUL ACCIDENT

This photograph is a spoiled mess. Water has evidently leaked onto it, causing the emulsion to run. It is the only item in the Simmons collection in such a condition. The damage reaches the lower part of Billie Holiday's dress but does not engulf her. The stained portion creates an almost accidental facsimile of the celebrated color woodblock print The *Great Wave off Kanagawa* by Japanese master ukiyo-e artist Hokusai.

Holiday appears a bit dressed down compared to the photo taken of her with Daddy-O Daylie. Nonetheless, her elegant drop earrings and stylish shoes project an air of sophistication. With her right hand raised waist high and her left hand clasping a white hankie, Holiday seems to be entreating the microphone. And through its amplification she is baring her soul to the audience.

Holiday's beauty and powerful presence are undeniably on show. The background banner reads "Sammy Dyer Presents." Dyer choreographed and designed musical revues at Club DeLisa for many years, often featuring his female dance troupe, the Dyerettes. Moreover, the sliver of insignia that remains visible on the bass drum could well be the monogram of the Red Saunders Band. These traces confirm that Holiday is performing on the Club DeLisa stage. After looking at the image for a while, the marred bits begin to recede.

The realization that this photograph has accrued its own history becomes apparent and arguably enhances its aesthetic value. This photo is, in fact, a treasure. Flaws and all.

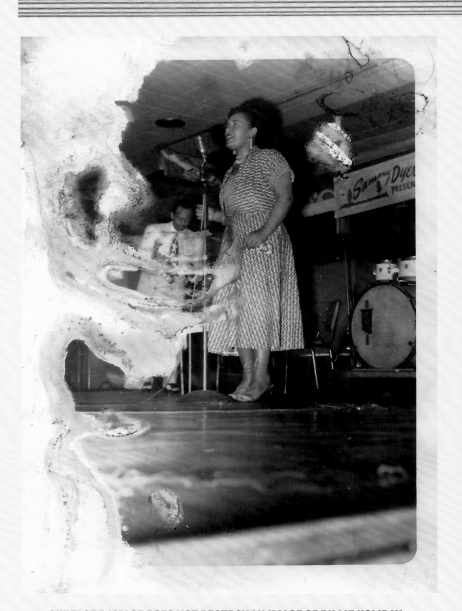

SURFACE DAMAGE DOES NOT DESTROY AN IMAGE OF BILLIE HOLIDAY.

confided that he no longer supported himself from his music. "I love to play," he said. "It's my hobby. But I get most of my money from renting out my fourteen organs and six electric pianos." Simmons had established Lonnie's Organ Rental in 1969.

An article by Ted Watson in the *Chicago Defender* in 1975 investigated what had happened to the singers, dancers, and musicians working during the heyday of the Bronzeville nightclub scene. Almost all of the twenty artists cited ended up at prosaic jobs, unrelated to performance. Dancer Muriel Zollinger, of the Regalettes, was a mixologist at a lounge on 75th Street. But chanteuse Viola Jefferson was a traffic court clerk. Others held positions with various city agencies: payroll, sanitation, and the board of election commissioners. George Floyd, a Club DeLisa singer, sold Cadillacs. Bassist Rail Wilson sold TVs at Sears. And still others worked in hotels and hospitals. Simmons was the only artist still working in his chosen profession.

Lonnie Simmons insisted that he would continue to work until the day he died. "When I stop playing that's when they'll be burying me," he told *Chicago Sun-Times* reporter Dave Hoekstra in 1988. Simmons was unwittingly prescient. He suffered a heart attack at age 80 while performing the New Year's Eve set at Biasetti's in 1994. He died from complications five weeks later.

The *Defender* took note of his passing. Earl Calloway wrote, "How significant it is that Simmons, a wonderful, monumental musician, served within the realm of the exceptional artist with many giants, continuing to be active for four score years."

The visual evidence provides irrefutable proof of Lonnie Simmons' robust participation in the Bronzeville jazz scene. And yet he has been almost entirely overlooked in the historical record. His close associate Red Saunders was much honored, dubbed "'Mr. Chicago': a legend in music" and "a pivotal figure in music." Not so Simmons, even though he was featured

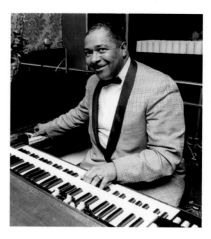

A SEASONED SIMMONS PERFORMS AT BIASETTI'S.

above Saunders on marquees.

There is no simple explanation for why recognition has eluded Lonnie Simmons, as either a musician or a photographer. His photos are notable for their quality and verve. They can be eye catching, breathtaking, and head-turning. Simmons suffused his images with allure and risk. Shadow and translucence. And the frisson of sexual prospects and the possibility of being let down. They provide a compelling record of a time gone by. It is a period enveloped in cigarette smoke and embodied in individual as well as collective memories that have steadily eroded.

ACKNOWLEDGMENTS

My writing has focused almost exclusively on the intersection of art and politics in South Africa for the past twenty years. This project allowed me to reacquaint myself with Chicago, a city I happily called home from 1974 to 1983. I am grateful to Melanie Dreher for allowing me to stay in her apartment while I conducted research. Where else could one encounter a bushy plastic cannabis plant next to a grand piano—all set against a sweeping view of Lake Michigan and the Loop?

I found it exciting and exhausting riding the Red Line of the "L" to one of my primary research sites. I traversed nearly the entire north–south expanse of Chicago, boarding at the Bryn Mawr Station (5600 north) and riding to its southern terminus at 95th Street–Dan Ryan. What a remarkable reintroduction to the city.

I would like to acknowledge the skilled research librarians with whom I consulted, especially those at the Vivian G. Harsh Research Collection of the Chicago Public Library, and at the Special Collections Research Center at the University of Chicago. They helped me unearth some of the rather sparse available information so I could reconstruct the life of Samuel "Lonnie" Simmons, and the rich musical scene in which he was a participant.

Ken Burkhart and Catherine McKinley share my passion for photographs. And my addiction to collecting them. They both offered many bits of strategic advice for this project. Ken and Catherine have also added a lively soundtrack to their viewing of images I regularly share with them for their invaluable comments and insights. Their vibrant choruses of wonder and delight are the best confirmation a fellow collector can receive.

Karen Shatzkin spent months guiding me through the legal intricacies of publishing a book such as this. We became dogged detectives, genealogists, legal researchers, and cultural historians. I am grateful to Karen for sharing her legal expertise as an advisor to creative producers. Her arguments and reasoning have helped me better understand how to present this material.

After looking through the first few shots of the mind-blowing acrobatic nightclub performers in this archive, I was hooked. I thank Roman Zangief for connecting me with this remarkable cache.

I recognized from the outset that CityFiles Press was the right publisher for this book. The *only* publisher, in fact. Look at a sample of their previous titles and you will understand why. The coalescence of photography, Chicago history, and vital racial and cultural matters made the Lonnie Simmons project a natural fit. My thanks to Richard Cahan and Michael Williams, with an acute visual sensitivity and a level of expertise honed over decades. What a pleasure and privilege to work with them.

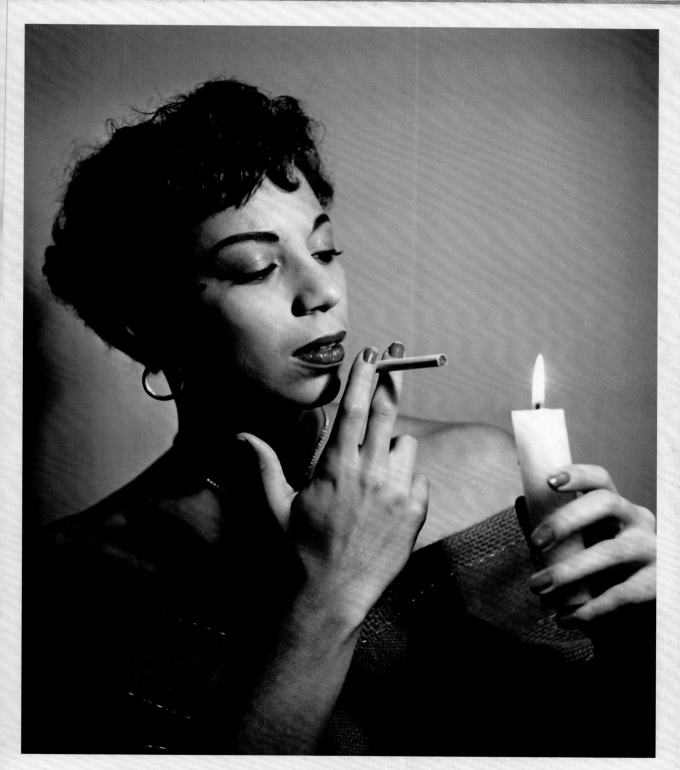

AN ALLURING WOMAN LIGHTING UP, A BYGONE VISION OF SENSUALITY AND SOPHISTICATION.

BIBLIOGRAPHY

Anon, n.d. "'Mr. Chicago': a legend in music," Edgar Crilly Collection, Box 1, Folder 8, University of Chicago Library Special Collections Research Center.

Black, Timuel D., Jr., 2019. *Sacred Ground: The Chicago Streets of Timuel Black.* Evanston, IL: Northwestern University Press.

Burley, Dan, n.d. "Tearing down of Grand [Theater] marks a forgotten life," clipping, no source listed. John Steiner Collection, Box 155, Folder 3, University of Chicago Library Special Collections Research Center.

Cabello, Tristan, 2008. "Bronzeville's Queer Nightlife Part 2: The Making of Bronzeville's Queer Culture (1940–1955)." OutHistory.org. Downloaded April 22, 2019.

Calloway, Earl, 1978. "Red Saunders, a pivotal figure in music," *Chicago Defender,* April 1: 3.

———,1978. "They honored Red— with dance and music," *Chicago Defender,* April 19: 19.

———, 1994. "Lonnie Simmons still active after all these years," *Chicago Defender,* July 2: 45.

———, 1995. "Services set for Simmons; musician, photographer," *Chicago Defender,* February 1995: 26.

Chicago Daily News, 1950. "Tenants fight slum eviction," June 6: 12.

Chicago Defender, n.d. "Bar white sailors."

———, 1936. "Taxi executive is shot by thugs," December 26: 1.

———, 1938. "Many races mix at Mike DeLisa's gay spot," January 8: 18.

———, 1938. "Club DeLisa packed nightly for new show," October 15: 19.

———, 1942. "Navy sets up 'Jim Crow' area in Chicago," July 25: 1.

———, 1942. "And now women must drink at tables," August 29: 4.

———, 1954. "Photographer helps cops nab robbers," August 21: 5.

———, 1954. "Slaying may close Club DeLisa," October 9: 5.

———, 1954. "Chicagoan kills self kissing murdered mate," November 27: 5.

———, 1955. "Wife sees mate shot to death at police station," February 26: 5.

———, 1957. "Meets death face to face," April 1:1.

———, 1958. "Rescued, then shot," February 1: 2.

———, 1958. "Bites off wife's nose during rage," July 14: 3.

Coleman, Gloria, 1980. "The DuSable Hotel locale: descriptive analysis of an area circa 1940–50." M.A. paper, Department of Inner City Studies, Northeastern Illinois University. Charles Walton Papers, Vivian G. Harsh Research Collection of Afro-American History and Literature, Chicago Public Library, "Bronzeville Conversations drafts," Box 3, Folder 2.

Culbert, Michael L., 1973. "Musician recalls black legacy: Red Saunders sounds off," *Chicago Defender,* September 1: 6.
Daniels, George, 1957. "Louis Jordan sounds thrill 800 in Chi," *Chicago Defender,* April 6: 8.

de la Croix, St. Sukie, 2012. *Chicago Whispers: A History of LGBT Chicago before Stonewall.* Madison: University of Wisconsin Press.

Drake, St. Clair, and Horace R. Cayton, 1945. *Black Metropolis: A Study of Negro Life in a Northern City.* New York: Harcourt Brace.

Duckett, Alfred, 1954. "Ella Fitzgerald, 'First Lady of Swing' rode a yellow basket to fame," *Chicago Defender,* July 31: 18.

———, 1954. "How tragedy brought fame, fortune to handicapped 3-leg dance team," *Chicago Defender,* August 14: 18.

Dinges, Barnaby, 1991. "Tavern tunes: after 23 years, Lonnie Simmons is still taking requests at Biasetti's," *Chicago Reader,* April 18.

Elledge, Jim, 2018. *The Boys of Fairy Town: Sodomites, Female Impersonators, Third-Sexers, Pansies, Queers, and Sex Morons in Chicago's First Century.* Chicago: Chicago Review Press.

Green, Adam, 2007. *Selling the Race: Culture, Community, and Black Chicago, 1940–1955.* Chicago: University of Chicago Press.

Green, Alfred, 2015. *Rhythm is My Beat: Jazz Guitar Great Freddie Green and the Count Basie Sound.* New York: Rowman & Littlefield.

Hirsch, Arnold R., 1998. *Making the Second Ghetto: Race and Housing in Chicago 1940–1960.* Chicago: University of Chicago Press.

Hoekstra, Dave, 1988. "Magic of Lonnie Simmons: at 73, storied organist," *Chicago Sun-Times,* January 15:7.

Jet, 1953. "Table eater teaches son unusual act," July 16: 2.

———, 1955. "Aerial flight," March 24: 32.

———, 1958. "With closing of Club DeLisa," March 6: 61.

Kellum, David W., 1939. "Backstage with the scribe" [column], *Chicago Defender,* February 4: 18.

———, 1940. "Backstage with the scribe" [column], *Chicago Defender*, April 13: 21.

Linderman, Jim, 2011. "Dull tool dim bulb." htpp://dulltooldimbulb. blogspot.com/2011/03/nightclub-photography-club-delisa-hard.html. Downloaded June 23, 2019.

Monroe, Al, 1947. "Cocktail bars replace cabarets in many cities," *Chicago Defender,* October 25: 18.

Morris, Earl J., 1936. "DeLisa Gardens newest revue is best in Chicago," *Pittsburgh Courier,* February 29: A7.

Nelson, Shirley, 1959. "The Shirley Nelson story (2): hard life play girl, bitter at church,"*Chicago Defender,* March 7: 12.

Ole Nosey, 1943. "Everybody goes when the wagon comes," *Chicago Defender,* June 2: 12.

———, 1948. *Chicago Defender,* February 21: 6.

Outlaw, Grace, 1995, "Businesses: beauty, burial, building, and Ben Franklin," n.d., reprinted in Stange, Maren, *Bronzeville: Black Chicago in Pictures, 1941–1943.* New York: The New Press, 2003: 193–95.

Roy, Rob, 1956. "Lonnie Simmons, 'Mr. Organist' is also a man of successful switches." *Chicago Defender,* May 5: 16.

———, 1957. "Operation music! From stage to other fields," *Chicago Defender,* January 19: 14.

Rubin, Fred, 1976. "Subterranean selections: Biasetti's," *Triad,* April: 74–5.

Segal, Joe, 1975. Liner notes to *Southside Jazz,* CHV—415. Chicago: Chess Records.

Semmes, Clovis E., 2006. *The Regal Theater and Black Culture.* New York: Palgrave Macmillan.

Sengstock, Charles. 1959. "Last traces of Jazz era disappear with Old Tech Center Buildings," no source listed, John Steiner Collection, Box 157, Folder 47, University of Chicago Library Special Collections Research Center.

"Simmons band closes Chicago Beige Room," n.d. Clipping in Lonnie Simmons archive, no source listed.

Stone, Theodore Charles, n.d. "At 70 Lonnie Simmons reflects on career." Clipping in Lonnie Simmons archive, no source listed.

Travis, Dempsey J., 1981. *An Autobiography of Black Chicago.* Chicago: Urban Research Institute, Inc.

———, 1983. *An Autobiography of Black Jazz.* Chicago: Urban Research Institute, Inc.

Walton, Charles, 1982. "A Bronzeville conversation with Milt and Mona Hinton," November 10. Charles Walton Papers, Vivian G. Harsh Research Collection of Afro-American History and Literature, Chicago Public Library, "Bronzeville Conversations drafts," Box 3, Folder 12.

———, n.d. "A Bronzeville conversation with Samuel 'Lonnie' Simmons & friend," November 10. Charles Walton Papers, Vivian G. Harsh Research Collection of Afro-American History and Literature, Chicago Public Library, "Bronzeville Conversations drafts," Box 3, Folder 20.

———, 1995. "Memories of Bronzeville," *Jazzgram* (Jazz Institute of Chicago) March: 1. Charles Walton Papers, Vivian G. Harsh Research Collection of Afro-American History and Literature, Chicago Public Library, Box 26, Folder 3.

Watson, Ted, 1974. "Burning Spear Club gutted by inferno," *Chicago Defender,* April 29: 12.

———, 1975. "Other jobs sustain former show folks," *Chicago Defender,*October 4: A4.

Wilkerson, Isabel, 2010. *The Warmth of Other Suns: The Epic Story of America's Great Migration.* New York: Random House.

Winkfield, O., n.d., "Short tour of points of interest on the South Side: 26th to 47th Streets," Federal Writers' Project, Negro Studies Project," reprinted in Stange, Maren, *Bronzeville: Black Chicago in Pictures, 1941–1943.* New York: The New Press, 2003: 6–7.

Wright, Richard, n.d., "Amusements in Districts 38 and 40," Federal Writers' Project, Negro Studies Project, reprinted in Stange, Maren, *Bronzeville: Black Chicago in Pictures, 1941–1943.* New York: The New Press, 2003: 193–95.

ABOUT THE AUTHORS

Steven C. Dubin received an MA and PhD from the University of Chicago. He was subsequently a postdoctoral fellow at Chicago and Yale. He directed the MA program in arts administration at Columbia University and was an affiliate of Columbia's Institute for African Studies. In addition, he has been a fellow at the Research Centre, Visual Identities in Art and Design, at the University of Johannesburg, and an honorary professor at the Centre for Creative Arts of Africa, University of the Witwatersrand, Johannesburg. Dubin retired from a lengthy academic career in 2018.

This is Dubin's eighth published book. His writing has primarily focused on controversial art and censorship, museum studies, culture and politics in South Africa, and African and African-American photography. His curatorial experience includes exhibitions ranging from Barbie to a found archive of photos from an apartheid-era portrait studio. He has also been a frequent contributor to *Art in America*.

Among many honors, Dubin was granted Fulbright fellowships to South Africa and Iceland; was twice appointed a visiting professor at Hebrew University, Jerusalem; and enjoyed two residencies at the Bellagio Center in Italy. He has presented a TEDx talk; was awarded a *New York Times* Notable Book of the Year designation; and was a winning contestant on Ca$h Cab.

Margo Jefferson, a Pulitzer Prize-winning critic, is the author of *Negroland,* which won the 2015 National Book Critics Circle Award for Autobiography, the International Bridge Prize, and the Heartland Prize. It was also short-listed for the Baillie Gifford Prize. She has been a staff writer for *The New York Times,* and her reviews and essays have been widely published and anthologized. She lives in New York and teaches in the writing program at Columbia University.